Edward Sheriff Curtis
Joanna Cohan Scherer

Edward Sheriff Curtis

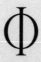

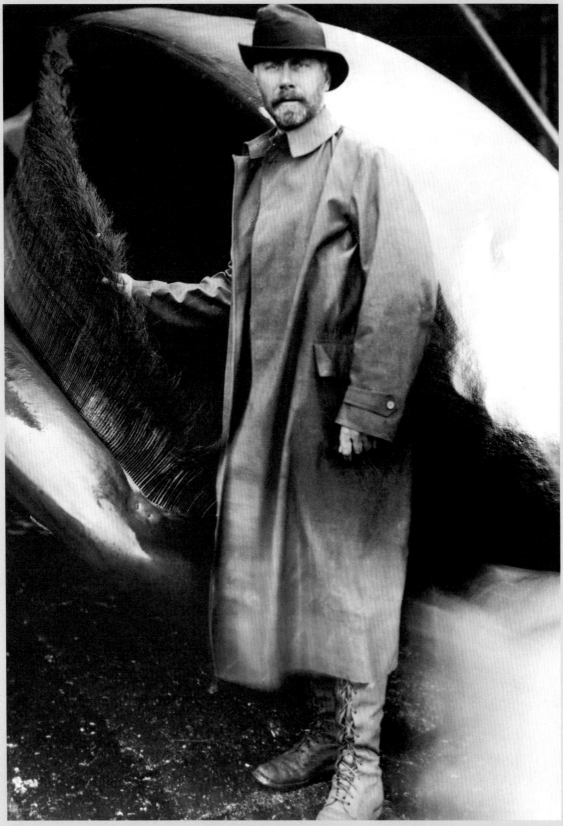

Photographer unknown,
Edward S. Curtis grasping
the dark baleen of a blue whale,
c.1912–14

Curtis boasted to Gifford Pinchot in August 1914 that during his summer field trip he had participated in 'a corking whale hunting trip, and I now almost consider myself a professional whaler'. Curtis cultivated the romance of the field trip and of himself as the archetypal outdoor adventurer. This promotional technique, which he articulated in his public presentations, was doubtless intended to keep his public on the edge of their seats. The photographer's name was not recorded.

Edward Sheriff Curtis (1868–1952), passionate recorder of Native American cultures, master art photographer, pioneer motion-picture maker, publicist and leader of an ethnographic team for thirty years, was a man of many talents and enormous energy. Although he was a prominent portraitist of early Seattle society and a landscape photographer of the scenery of the Northwest, it is for his images of Native Americans that he is best known. These pictures, made between 1900 and 1927 in collaboration with his field researchers, were intended to preserve a record of traditional life that was believed to be on the brink of disappearance. In fact, such cultures have not disappeared, but have flourished in the years since Curtis made his photographic record. None the less, his work is so significant and so widely disseminated that it has played a major role in shaping the image of Native Americans ever since.

Curtis was born in Wisconsin where his father, Johnson Curtis, and his mother, Ellen Sheriff Curtis, raised four children: Ray, Edward, Eva and Asahel. Soon after Asahel's birth the family moved to southeastern Minnesota, near the area of Cordova in Le Sueur County. Along with his brother Asahel, Edward became interested in photography while still in his teens, making his own crude cameras and teaching himself techniques from books.

In 1887 the family moved to Sidney (now called Port Orchard) in Washington State, a small township on Puget Sound, across from Seattle. But within a few months Johnson Curtis died of pneumonia. Edward, then only twenty, took on the responsibility of supporting his mother, sister and younger brother by working on the family farm.

In 1891 Edward moved to Seattle and the following year married Clara Phillips, whose family had recently moved from New Brunswick in Canada via Emporium, Pennsylvania. Their first child, Harold, was born in 1893, followed by three daughters, Beth, Florence and Katherine. It was here in Seattle that Curtis began his commercial photography career, at first in partnership with Rasmus Rothi, but from 1892 with Thomas H. Guptill, with whom he specialized in portrait photography (pages 32, 33). Curtis also engraved printing plates for reproductions of drawings, and Asahel went to work as an engraver for his brother's business. In 1896 Curtis and Guptill felt confident enough to submit over one hundred portraits of Seattle's leading citizens for exhibition at the National Photographers' Convention in Chautauqua, New York State, where they were awarded a bronze medal. Despite this success,

however, Guptill left the partnership the following year and Curtis became the sole owner of the business. At about this time Asahel began taking photographs for his brother's studio.

Late in 1897 the two went on a brief expedition to Alaska to capture images of the Klondike Gold Rush, which had burst on to the national scene in the summer of 1897. Edward soon returned to Seattle, but his brother remained in the region for two years. Asahel Curtis's images of Northwest Coast, Eskimo, Subarctic and Plateau tribespeople show him to be an accomplished and productive photographer, though they are less pictorial than his brother's and more documentary in nature.

In the mid-1890s, with the portrait photography business flourishing, Edward took his first photographs of Northwest Coast Native Americans in and around Seattle. It was about that time that he met and photographed 'Princess' Angeline, one of his most famous early subjects (page 19). She was the daughter of Chief Sealth (after whom the city Seattle was named), a leader of the Southern Coast Salish tribal group known as the Duwamish-Suquamish. Curtis also photographed local Native Americans who had entered into the Euro-American cash economy as hop-pickers in the fields around Seattle.

The scenery of the Northwest coast held a particular appeal for Curtis, especially the area of Mount Rainier where he was fond of hiking and camping, and where he made many landscapes. He was a member of the Mazamas Club, an organization for local mountaineers based in Portland, Oregon. Curtis would later recall helping a lost climbing party during one of his mountain excursions. Bringing them back to their camp, he discovered that several were eminent scholars: Dr C. Hart Merriam, naturalist, physician and chief of the Biological Survey of the US Department of Agriculture; Dr George Bird Grinnell, editor of *Forest and Stream* magazine and a well-known student of Native Americans from the Plains culture area; Gifford Pinchot, chief of the US Forestry Department; and Frederick V. Coville, chief botanist of the US Department of Agriculture. According to Curtis, he guided the party throughout the remainder of their climbing expedition and upon their return to Seattle showed them his photographs of the Puget Sound region.

Probably as a result of this chance meeting, Curtis was asked to join the Edward H. Harriman Expedition to Alaska in 1899. Harriman was president of the Union Pacific Railroad and a wealthy financier and industrialist from New York. He financed and participated in this expedition, which gave many natural scientists the opportunity to describe, photograph and chart the resources of Alaska. In addition to Grinnell, Pinchot and

Merriam, other well-known participants included the naturalists John Muir, John Burroughs and William H. Dall. The Harriman Expedition lasted from 31 May to 30 July and provided Curtis with an insight into scientific method. Lectures were given on board ship, and from these experts Curtis learned the field techniques that he used later in his research. As the official photographer of the expedition, Curtis produced mainly landscape views, and a few ethnographic images (pages 20–21, 22–23). Merriam, also a photographer, took most of the Native American images. In all, about five thousand photographs were made. Curtis received no salary, but it was agreed that he could sell his prints to individual members of the expedition. There were 126 participants, and Harriman reportedly had a souvenir photo album made for each one. Curtis devoted much time to the task, with Merriam advising on the cropping of images and final preparation of the albums.

In 1900 Curtis bought out the photo studio and negatives of the Seattle photographer Frank La Roche, who himself had a large collection of Native American photographs, and it was this studio that became Curtis's Seattle workshop. It was a busy time for him: he was active in photographers' associations both in Seattle and elsewhere in the northwest, and in 1901 he became a vice-president of the Photographers' Association of the Pacific Northwest.

Curtis's interest in systematically documenting a wide range of Native American cultures seems to have begun shortly after the Harriman Expedition. In the summer of 1900 Grinnell invited Curtis to accompany him on a visit to the Blackfeet Reservation in northwestern Montana to photograph the annual Sun Dance ceremonies. Perhaps it was Grinnell's influence that led Curtis to view Native Americans as a 'vanishing race'. However, rather than disappearing, as Curtis feared, the Native Americans were in fact beginning to increase in numbers. Nevertheless they were undergoing vast cultural changes driven by Christianity and Euro-American immigration, and the fact that Curtis photographed them during this period of rapid change was fortuitous. He became obsessed with the idea, and his compulsion to photograph, record, and share with the world through publication every aspect of Native American life became his driving force for the next thirty years.

By late 1903 or 1904 Curtis was working away from the studio for most of each year, which put a great strain on his family life. His marriage to Clara faltered in 1909 and they became legally separated, though the divorce was not finalized until 1919. He was perpetually unable to pay alimony, and in 1927, returning from one of his research trips, he was arrested for failure to do

so for the previous seven years. When the judge asked why Curtis was working for so long at a project that would never show a profit, he replied:

> Your Honor, it was my job, the only thing I could
> do that was worth doing ... a sort of life's work ...
> [I] was duty bound to finish. Some of the subscribers
> had paid for the whole series in advance.

His project became his passion; at the age of eighty-three Curtis summed up his work ethos: 'Following the Indian form of naming man I would be termed "The Man Who Never Took Time to Play".'

Curtis's hugely ambitious and expensive project could not have become a reality without the support and encouragement of President Theodore Roosevelt. His work came to Roosevelt's attention in 1903 as a result of a competition for photographs of 'the most beautiful children in America'. Curtis's image of Marie Octavie Fischer was published in the *Ladies' Home Journal*, and she was judged one of the twelve prettiest. The winners were to be painted by Walter Russell, a prominent society portraitist, who knew Roosevelt and introduced Curtis to him. In 1904 Curtis was asked to take photographs of the Roosevelt children, and two years later he was invited to take portraits of Alice Roosevelt's wedding. Roosevelt's enthusiasm for Curtis's project was to be more publicly acknowledged when he wrote a glowing foreword for the first volume of *The North American Indian*, published in 1907.

Roosevelt encouraged Curtis to meet and present his planned project to men of wealth who could subsidize it. How Curtis became known to the financier John Pierpont Morgan is not certain, but in 1906 Morgan agreed to fund fieldwork for Curtis and set up a company called The North American Indian Inc. He initially gave Curtis $75,000, and was himself to receive twenty-five sets of the original edition; each set was to cost between $3,000 and $4,700. Morgan supported Curtis until his death in 1913, when his son took over the funding. Curtis planned to publish 500 sets of volumes and folios but in fact was able to sell only 272 to a wealthy, elite minority. A 1908 prospectus announced that the work would 'consist of twenty volumes of text, each consisting of about three hundred and fifty pages. Embodied with the text there will be fifteen hundred full-page photogravure plates, some forty of which will be hand colored. In addition there will be twenty portfolios, each consisting of thirty-six or more copper-plate photogravures.' In the end Curtis published 2,232 photogravures in the portfolios and bound volumes. The books were printed on special handmade paper, the typography was carefully chosen and the illustrations were finely engraved; the

plates and printing were done in Boston, and the binding in New York. That the costliness of the work prevented it from reaching a wide market was unfortunate, since the original intention was for it to appeal to the general public.

The tribes that Curtis photographed were mainly from the western part of the United States and Canada, and included those from the Plains, Great Basin, Plateau, California, Northwest Coast, Arctic and Subarctic culture areas. 'Culture areas' refers to groups living in the same geographical area who share cultural patterns and more frequent historical interaction. He did not work among any of the tribes east of the Mississippi, nor among the groups of eastern Canada. Curtis's stated aim was 'to give a complete record of all the tribes of North American Indians, within the limits of the United States, which are at the date of these studies living in anything like a primitive condition'. Thus his omission of eastern tribes was purposeful – even when he did fieldwork in Oklahoma in the mid-1920s, he did not photograph the eastern tribes living there because he found them too 'civilized' and not living in a 'traditional' manner.

Curtis considered himself primarily a photographer, but his publications described and reconstructed Native American culture through a combination of text and photographs. There was always a struggle between information-gathering and the main focus of the work, picture-taking. Thus the collecting of data was done, by and large, by his assistants who all published under his name. They recorded vocabulary in the various native tongues, songs and music, mythology and general cultural information including details of dwellings, clothing, political arrangements, kinship, social organization and subsistence. One of his most important assistants was William E. Myers, a former Seattle newspaperman, who did most of the research for and writing of volumes 1 to 18 between 1906 and 1925. Curtis said that Myers was an astonishing asset because of his uncanny ear for phonetics, which proved invaluable in recording word lists. Stewart C. Eastwood replaced Myers in 1926 working in Oklahoma and Alaska. Frederick Webb Hodge, ethnologist at the Smithsonian Institution, was entrusted with editing Myers's, Eastwood's and Curtis's text on a freelance basis, Adolph F. Muhr printed all the images, and Charlie Day (a trader at the Navajo Reservation) helped in collecting Navajo material (pages 42, 43). Native American consultants were Alexander B. Upshaw, a Crow who was Curtis's interpreter from 1905 until his death in 1909; George Hunt, part Tlingit, but raised in a Kwakiutl village; Sojero, a Tewa-speaking Pueblo Indian and Paul Ivanoff, a Russian/Eskimo interpreter

who assisted in Alaskan research (pages 118, 119). The project was therefore a collaborative effort and should be recognized as such.

In order to promote his project, Curtis gave public lectures and created 'entertainments' based on Native American subjects. The lectures were either illustrated by lantern slides or given at special exhibitions of his photographs. Later he also used film footage in his presentations. He produced, for example, a lavish show based on Native American life billed as 'Edward S. Curtis and his Picture-Musicale — *A Vanishing Race* — illustrated by the most wonderful and beautiful art pictures of Indian life — both still and moving — ever secured.' The production was shown in New York at Carnegie Hall, the Brooklyn Institute and the Hippodrome, and went on a national tour between 1911 and 1913. Unfortunately, because the costs were substantial there is little evidence that Curtis's tours were successful in their original aim of either making money or increasing subscriptions to *The North American Indian*. Moreover, Curtis came under criticism from professionally trained anthropologists for this popularization. Indeed, these 'picture-musicales' served to perpetuate the myth of the exotic otherness of Native Americans and the ideology of them as 'the vanishing race'.

At a lecture in Seattle in 1907 Curtis gave some insight into his project. He said: 'You ask me to tell you something of my work that would be of interest to photographers … To begin with, for every hour given to photography two must be given to the word picture part of this record of the vanishing Indian. True, many of the hours given to the writing are those of the night time … The everlasting struggle to do the work, do it well and fast, is such that leisure and comfort are lost sight of … How do I manage the portraits and the handling of the life? In every way. Conditions cannot be changed. I must fit myself to them. Some of the portraits can be made in my tent, which is a fair sized one made for photographic work. More are made in the open, in the soft light of the morning or in the intense glare of the midday sun. The subject secured, it matters not the time or conditions. The picture must be made.'

In addition to his still photography Curtis made a number of films, and around 1910 he conceived the idea of a commercial full-length motion picture. He decided to focus on the Kwakiutl of Fort Rupert in British Columbia, a Northwest Coast group whose ceremonial life was, in Curtis's own words, '… a veritable pageant. It is, perhaps, safe to say that nowhere else in North America had the natives developed so far towards a distinctive drama.' The Kwakiutl cooperated enthusiastically in the filming of his fictionalized material based

on their nineteenth-century lifestyle, going so far as to make new costumes based on traditional types. This eagerness to participate may have been a way of thumbing their nose at the government's prohibition of many of the same activities and ceremonies that Curtis was filming. The film, completed in 1914 and titled *In the Land of the Head-Hunters*, was acclaimed by reviewers but had no great box-office success.

In a letter dated 2 May 1912 to Charles D. Walcott, Secretary of the Smithsonian Institution in Washington, DC, in which he discussed his ideas for filming among the Northwest Coast tribes, Curtis wrote: 'As I see it, it is most important that great effort be made to have all costumes absolutely correct. To do this requires a great deal of preliminary work where a picture is to be made, and at times a heavy expense. Some of those in consultation have felt that it would be better to ... use such costumes as occur, rather than to be so exact in costuming ... Pictures should be made to illustrate the period before the white man came, keeping in mind all their activities.' From the beginning Curtis intended his films and photographs to reveal how Native Americans looked in their 'traditional' pre-contact ways of life, before Euro-American influence took hold. Walcott responded on 4 May: 'Your plan to make a permanent motion-picture record of the existing primitive life of our Indians while the opportunity still lasts, and to restore scientifically, so far as may be practicable, that part of their life that has passed, is so important to education that I am very much pleased to know that there is a prospect of this work being done. It is almost needless for me to say that unless the pictures are made in a scientific manner — that is, unless all intrusive elements are eliminated so far as practicable and the illustrations made to show the Indians and their activities as they were before white men came among them — the plan would scarcely be worth the time and expense.'

Walcott's response is significant as it counters contemporary criticism of Curtis's *magnum opus*. Some writers have condemned him for removing signs of Euro-American culture, for staging scenes and for altering images after the fact. Yet, as Walcott's letter shows, Curtis followed the accepted methods of the time. The established academic community promoted such manipulation of images in order to create an 'ethnographic present' in which the subject was depicted dressed and engaged in activities believed to represent the pre-contact period. Thus, as in most of the ethnographic studies of the period, it is 'memory culture' that is emphasized, not the culture that existed at the time of recording.

Curtis was sixty-two years old, in debt and in ill health when he completed the last volume of *The North American Indian* in 1930. He had even given up the copyright on the photographs

to the Morgan Trust during the period 1923–28. He spent two years, from about 1931 to 1933, recovering his health in Denver. Later he took some interest in his Los Angeles studio, then being run by his eldest daughter, Beth. He also supplemented his income by working in the Hollywood film industry as a cameraman, an activity he had begun in the early 1920s. In 1936 he went to South Dakota to film *The Plainsman*, starring Gary Cooper, which he sold for $1,500. The film portrayed Buffalo Bill and General George Custer, and the cast included several hundred Teton Sioux from the Rosebud Reservation in South Dakota. In the 1940s he spent some time farming and began a book on gold mining; he also worked occasionally on his memoirs which were, however, never published.

Edward S. Curtis died on 21 October 1952 at the age of eighty-four at the home of his daughter in Los Angeles. He had lived long enough to see interest in his photographs of Native Americans wane and disappear. In 1935, when he was in debt, he had sold the original copper photogravure plates for *The North American Indian* — representing an investment of about $100,000 — to the Charles Lauriat Company, a rare book dealer in Boston. They were rediscovered at the Lauriat Bookshop in the 1970s. Since then Curtis's fame has grown: today he is widely considered the foremost photographer of Native Americans, by both specialists and the general public. He is a role model for photographers of the twenty-first century, who articulate their wish to produce Curtis-like bodies of work; modern-day painters are inspired by his photographs; ethnologists use Curtis's materials in their research. His work is also valued by many Native Americans themselves. The Gros Ventre, for example, consider Curtis's collection of songs and photographs a primary resource for their tribe.

What is it that makes Edward Curtis's images so exceptional? In the first place, his subject captures viewers' imaginations: the allure of the 'exotic other'. Importantly, there is also the artistic quality of the images themselves. Curtis came of age in the 1890s when many photographers were attempting to assert their creativity as artists and to distinguish themselves from the more documentary commercial photographers and the growing throngs of amateur photographers. Previously, photography had been considered a mechanical invention that simply captured whatever was in front of the camera. But soon photographers became active agents, manipulating their subjects by posing and costuming, and the overall effect through lighting and printing artifice, thereby creating special pictorial effects that ultimately

influenced the image. Such characteristics as the domination of a single tone in a photograph, avoidance of detail, and a softening effect so that objects were viewed as though through gauze, are all characteristics of Curtis's artistic style that helped him produce the spectacular images he sought.

The primary goal of Pictorialist photographers like Curtis was to produce a body of work for its artistic quality. Yet if approached with caution, his Native American images can also be used as historical and ethnographic records. Despite his Pictorialist conventions, many of these photographs are accurate ethnographic documents of how the subjects themselves wished to be portrayed, and do provide information about Native American culture. Unquestionably Curtis had an agenda that cannot be separated from the ideology of his time, but this does not negate the ethnographic value of his images.

Curtis was, above all else, a photographer of memories who intended to capture images of a 'vanishing race'. His subjects remembered traditional ways of life and they actively helped him create his photographs by putting on their traditional clothes and demonstrating the use of old-style tools and weapons. The pictures themselves are not untruthful; memories and their re-enactment are part of the self-image of any individual. At the same time, all photographers have an agenda and point of view, but this does not negate the value of their work. It only means that viewers must be critical in 'reading' their photographs. We cannot take Curtis's photographs at face value, but must probe into the historical circumstances of the creation of each image. By maintaining a critical perspective we can appreciate Curtis's accomplishments in relation to the history of pictorial photography in America and to the popular construction of the image of Native American life during the early-twentieth century. That Curtis and company succeeded so well in recording systematic data on Native American cultures, including a unique photographic record, was a remarkable accomplishment. That many of his photographs are used today by Native Americans is a testament to this singular man's unique vision.

Note
All bibliographical references in the following pages are to Curtis's publication *The North American Indian*. Curtis's spelling of tribal names often varies from the modern spellings now attributed. The titles of all photographs shown here are those given by Curtis either in his books or for copyrighted or exhibited prints with the spelling he used, while modern terminology is used in the descriptive text. In addition, Curtis copyrighted many of his photographs years after they were taken, so where only the copyright date is known, the date is given as 'before' this date.

Biography

1868	Born in Wisconsin to Johnson Curtis and Ellen Sheriff Curtis.
1887	Family moves to Puget Sound in western Washington State. Johnson Curtis dies.
1891	Moves to Seattle. Rothi and Curtis Photographers established.
1892	Marries Clara Phillips. Enters into partnership with Thomas H. Guptill.
1896	Takes his first Native American photograph. His portraits and landscapes win him a bronze medal at the National Photographers' Convention in Chautauqua, New York State.
1897	Guptill leaves the partnership and Curtis becomes sole owner. He travels to Alaska with his brother Asahel to document the Klondike Gold Rush.
1899	Becomes official photographer of the Edward H. Harriman Expedition to Alaska.
1900	Is invited to visit the Blackfeet Reservation in Montana to photograph the Sun Dance. Makes his first independent field trip to Arizona to photograph the Hopi, Navajo, Apache and Mohave. Purchases the studio and negatives of Frank La Roche.
1904	Photographs President Theodore Roosevelt's family.
1906	Secures funding for *The North American Indian* from John Pierpont Morgan.
1907	Publishes the first volume of *The North American Indian*, featuring the Apache and Navajo.
1909	Separates from his wife.
1911	His production of slides and music, *The Vanishing Race*, begins to tour America.
1913	John Pierpont Morgan dies and his son Jack continues to support Curtis's project.
1914	Completes his motion picture *In the Land of the Head-Hunters*.
1919	Divorces.
1920	Moves to Los Angeles with his daughter Beth Curtis Magnuson and works as a cameraman in Hollywood.
1927	Makes his last field trip for *The North American Indian* to Alaska with his daughter Beth. Is arrested on his return to Seattle for failure to pay alimony.
1930	The twentieth and final volume of *The North American Indian* is published, describing some of the Eskimo in Alaska.
1931–33	Retires to Denver for reasons of ill health.
1935	All materials from *The North American Indian*, including copper photogravure plates, are sold to the Charles Lauriat Company, Boston.
1936	Films *The Plainsman*, starring Gary Cooper.
1940s	Undertakes research for a book entitled *The Lure of Gold*; it is never completed.
1952	Dies on 21 October at his daughter Beth's house in Los Angeles.

Nez Percé Babe, before 1900

The Nez Perce (modern spelling), who lived in the Plateau culture area in northern Idaho, made cradleboards of hard wooden planks to which were laced pouches made of tanned hide or, in later times, of canvas. A pack line was fastened through the holes on either side of the upper end of each plank, which allowed the cradleboard to hang down the mother's back, or, when riding, on the pommel of a saddle. Both the cradleboard and pack line shown here are beaded with a floral and geometric motif. A cloth, laid over the headboard, formed a hood for the child's head. The cradleboards were lined with mosses and down from cattail or milkweed. This photograph was probably made in Curtis's Seattle studio.

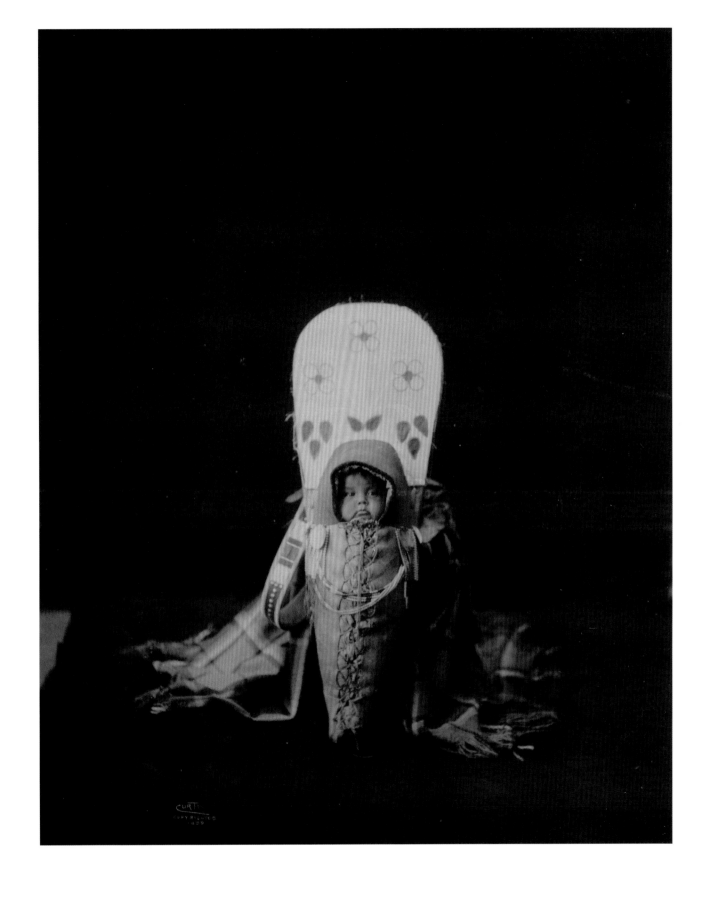

Princess Angeline, 1896

'Princess' Angeline was one of Curtis's first Native American subjects. She was the daughter of Sealth, a Southern Coast Salish leader from the Duwamish-Suquamish tribe in the Northwest Coast culture area. In the Treaty of Point Elliott in 1855 Sealth, along with other leaders, gave up the land on which the city of Seattle now stands. Curtis recalled years later, 'I paid the princess a dollar for each picture I made.'

One of his photographs of Angeline — digging clams out of the Puget Sound mudflats — won a prize at the 1899 National Photographers' Convention. Shellfish was a favourite food of the Southern Coast Salish and included cockles, bay mussels, oysters and various types of clam. So abundant were they that they were often dried for future use or traded inland.

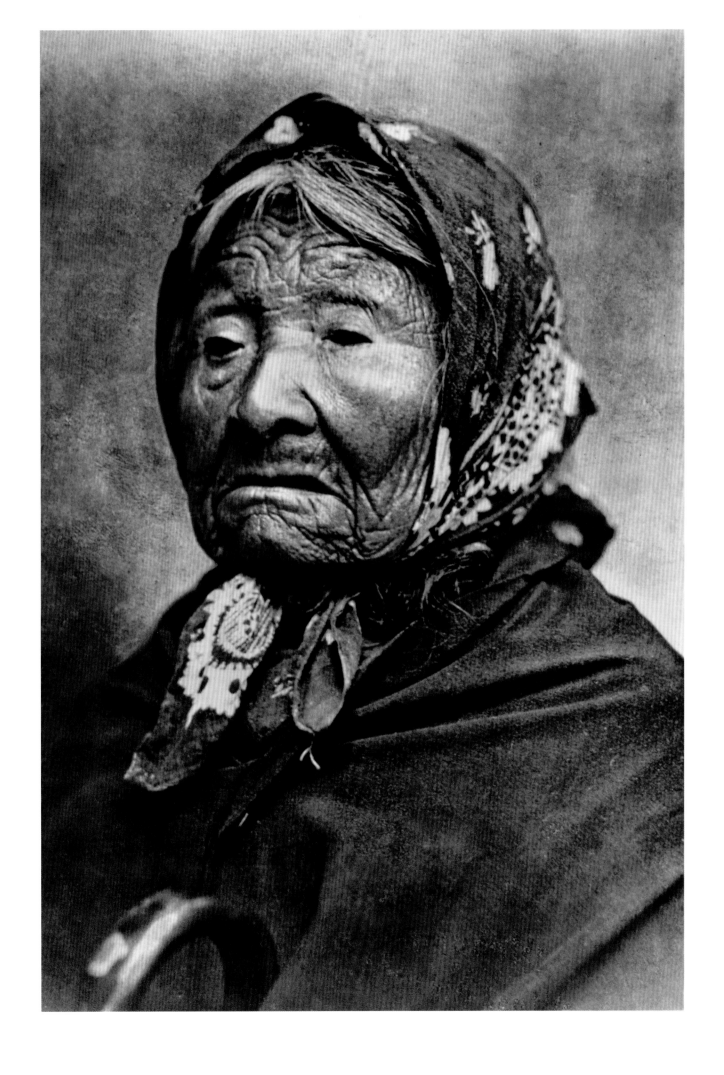

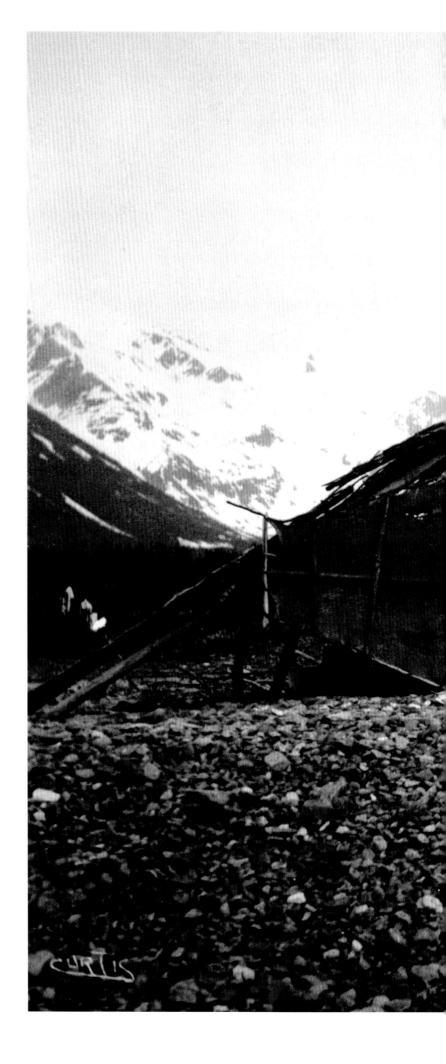

A Yakutat Indian
Seal Hunter's Hut, 1899

The first trip Curtis made to Alaska was as a member of the Edward H. Harriman Expedition. As official photographer, Curtis recorded the geology of the area and its dramatic landscapes, the plants and animals, the native population and their material culture. One of the expedition's stops was Yakutat Bay, a local settlement of the Tlingit, a people of the Northwest Coast culture area based mainly on the southeastern Alaska panhandle. The Yakutat were expert sealers and traded seal skin and oil to other Tlingit groups. The skins were used for clothing and the meat was dried for later consumption. The stomachs were made into floats to attach to harpoons when hunting, and the blubber was rendered into oil. This temporary structure contrasts dramatically with the large wooden plank houses that were typical of the Tlingit winter villages.

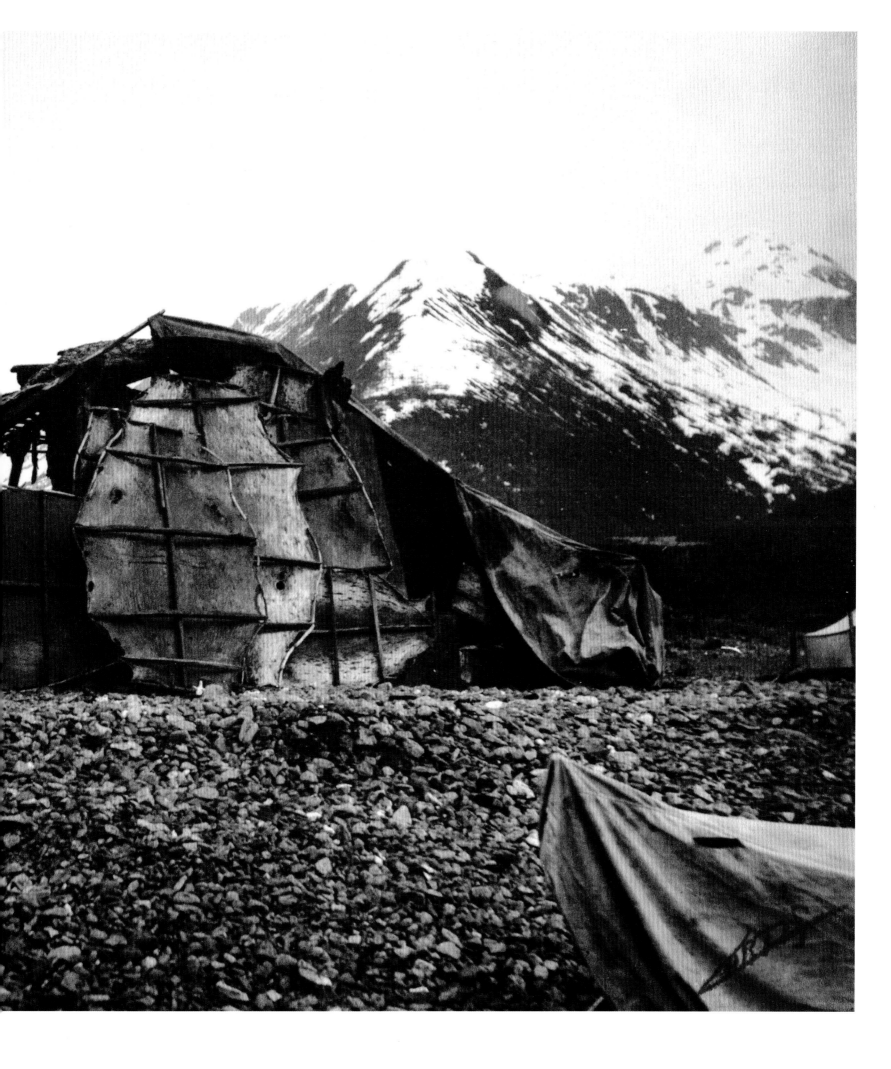

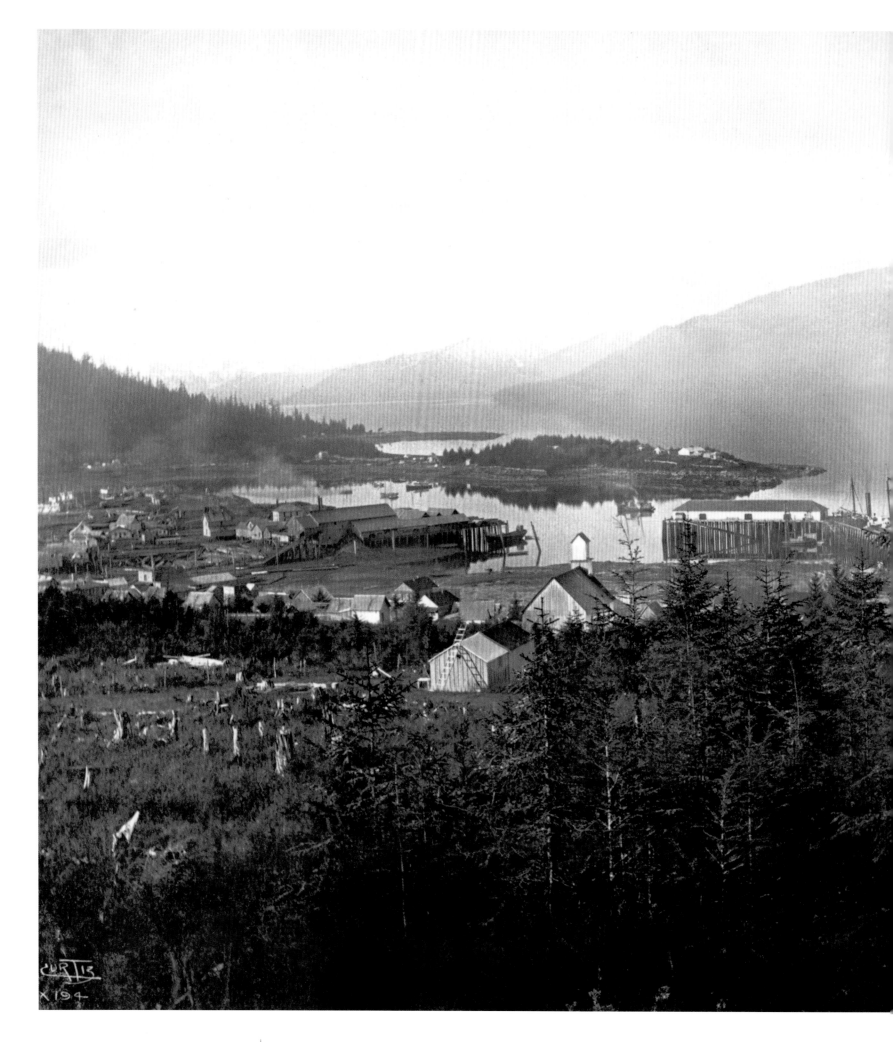

COPYRIGHTED
1899
E.H.HARRIMAN

Panoramic view of Wrangell,
Alaska, 5 June 1899

This photograph, taken on the
Harriman Expedition, shows both the
Euro-American town and the modern
houses of the Tlingit village. It is an
example of a Curtis picturesque
landscape, artfully framed to show
both the grandeur of the scenery and
mankind's presence. In 1899 Curtis
advertised that, 'As official photographer
for the Alaska Harriman Expedition
I secured a large number of pictures that
are entirely new. Catalogue of these views
will be available for mailing by August
15th, 1899. A number of especially fine
photographs of Indian life. Mail orders
will receive prompt attention.'

Weasel Tail (also known as Aapohsoyisa) was a member of the Blood tribe of the Blackfoot from Canada, a group living in the Plains culture area. During his youth he lived for some time among the Crow. Curtis photographed him on the Blood Reserve in Alberta where he was well-known as a tribal historian, famous for his ability to recount events of the past. He was a successful warrior and some of his stories related his prowess on horse-stealing raids. Such raids were evidence of a man's bravery and tribal wealth was measured in the number of horses owned. He is shown here wearing a war bonnet of eagle-feathers decorated with white ermine skins, thought to protect the wearer in battle. He also wears a grizzly bear claw necklace. Weasel Tail painted depictions of his exploits on panels, including one in which he jumped on the back of a grizzly bear and killed it with his knife.

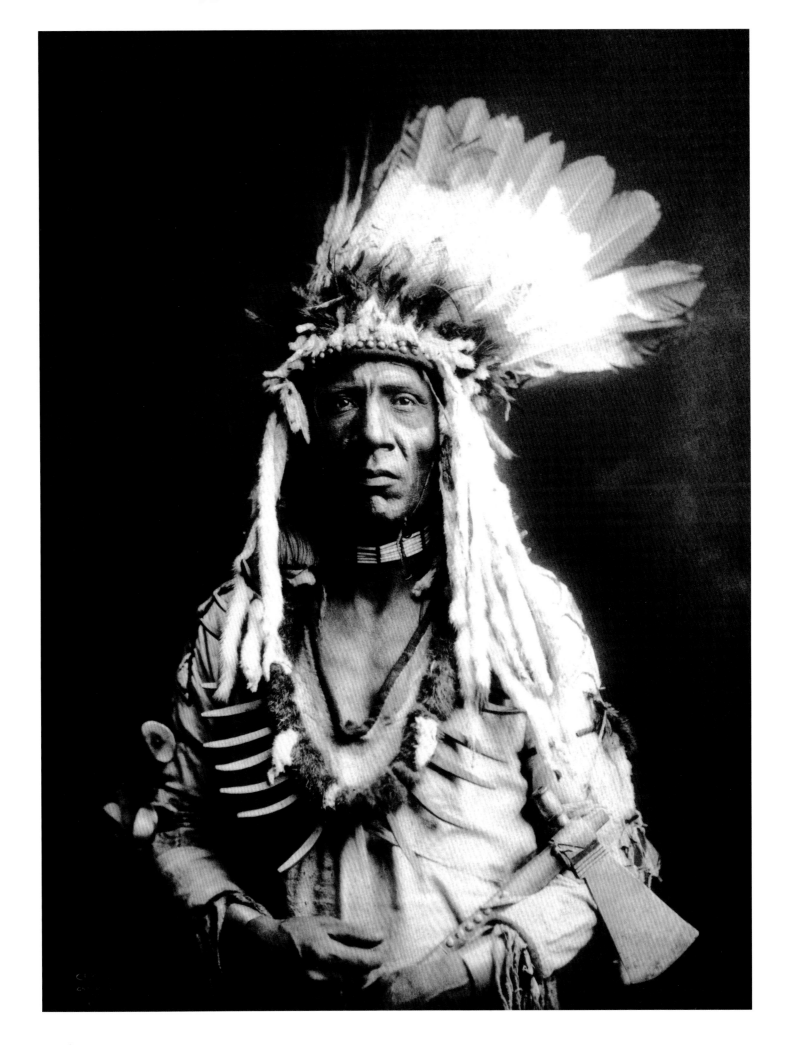

This is an image of Four Horns, Small Leggings and Mountain Chief: 'Three proud old leaders of their people. A picture of the primal upland prairies with their waving grass and limpid streams. A glimpse of the life and conditions which are on the verge of extinction' (volume 6). They were leaders of the Blackfoot tribe known as Piegan. This photograph, with its reflection of the men in the water, the wind-blown prairie and clouded sky, is a stunning example of the picturesque images Curtis could create. The mounted men — not close enough to be easily identified and dressed in their traditional clothing — become part of the natural landscape and, facing the fading light, serve as a visual metaphor of the demise of the Native American. The myth of the 'vanishing Indian' was, however, just a myth. Curtis's photographs were intended for a wide audience and presented his agenda of an imagined Native American from the past, rather than the reality of life for the people he pictured.

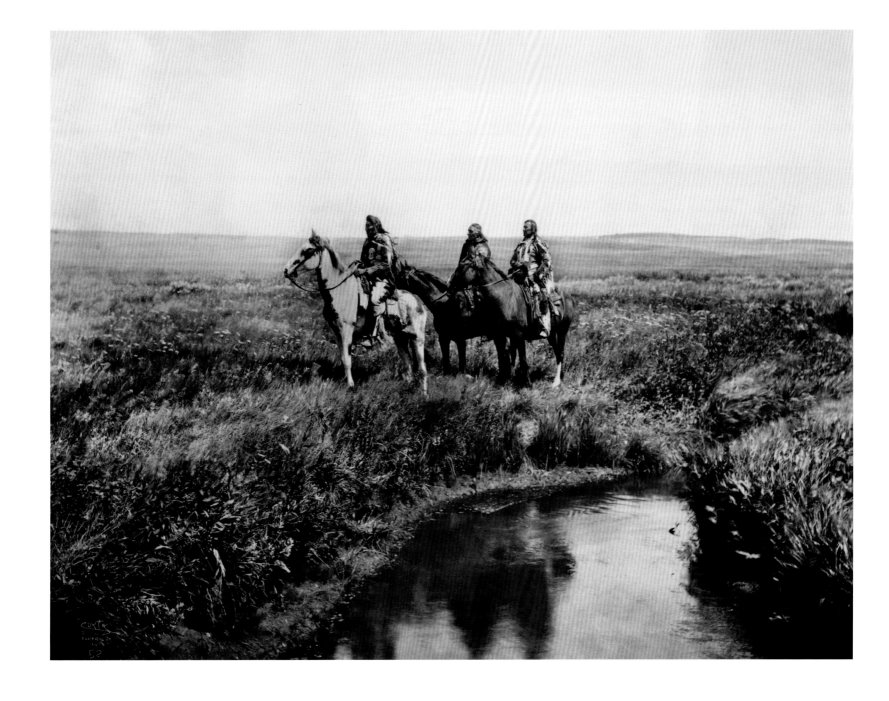

The Boy and the Short Man –
Gros Ventre, 1900

The Gros Ventre are a people of the
Plains culture area in northern Montana.
Both men pictured here are wearing
Grass Dance regalia that includes hair
roaches made of deertail or porcupine
hair, beaded wrist and arm bands, knee
bands with bells, and breastplates with
mirrors attached. Short Man (right) has
removed his back bustle and holds it it in
his hand. The Gros Ventres received the
Grass Dance from the Sioux in the 1870s.

Originally a celebration of war deeds,
the dance became a men's social dance
and is still performed today, usually as
part of a powwow. The Boy (left), who
was born around 1872 and died in 1957,
was an authority on Gros Ventre culture
and served as an officer in the Grass
Dance throughout his life. To hold an
office in the Grass Dance was a great
honour: it bestowed authority on an
individual but also obligated him to

lavish gift-giving, including food,
money, horses, cows, blankets,
overcoats, harnesses, saddles and so
forth, redistributing goods within
the community.

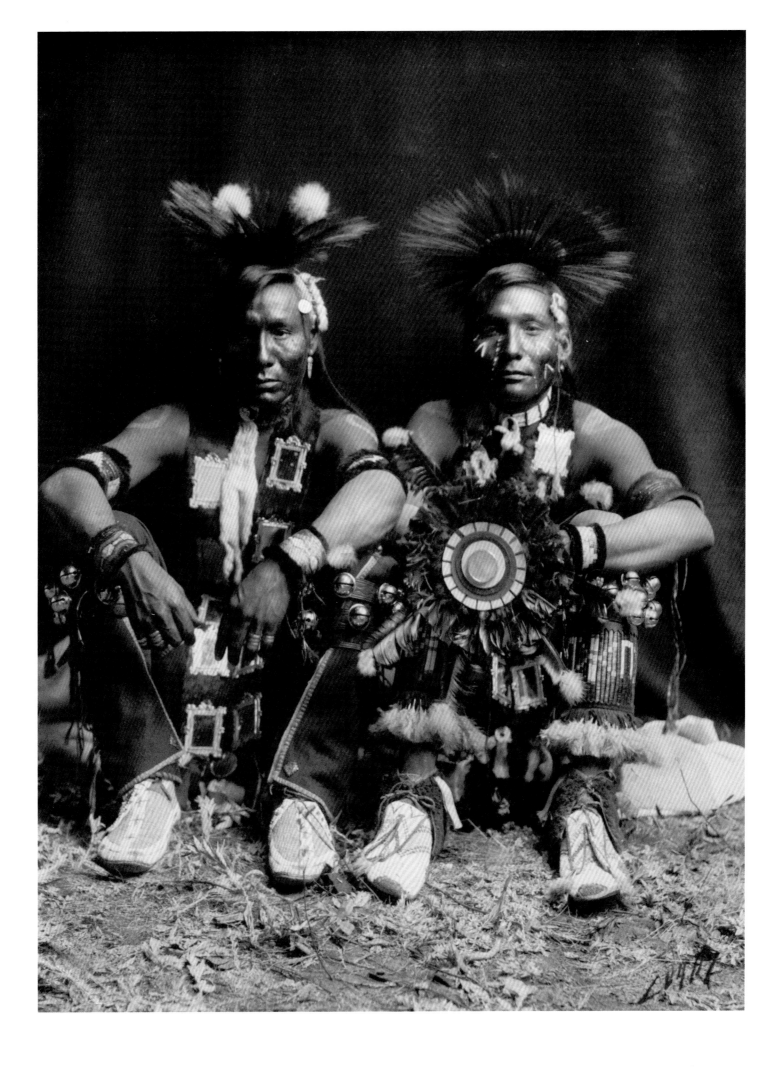

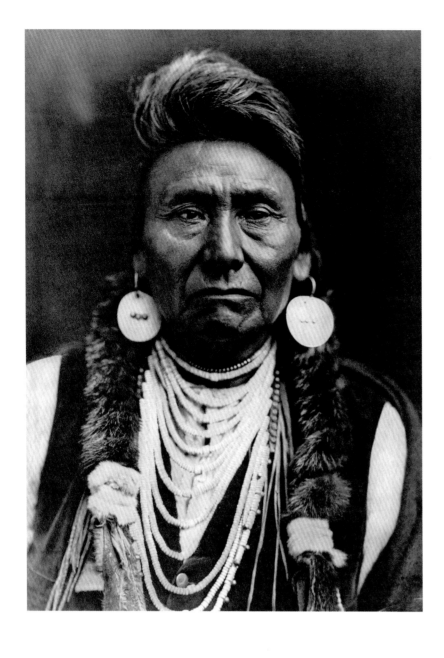

Chief Joseph – Nez Percé, 1903

'The name of Chief Joseph is better known than that of any other Northwestern Indian' claimed Curtis in volume 8 of *The North American Indian*. In 1877, after Chief Joseph's band was captured during their flight for refuge in Canada, he and his people were imprisoned, first in Indian Territory, and then on the Colville Reservation in Washington State. In his unsuccessful attempt to allow his people to return to their home in the Wallowa Valley, Oregon, Chief Joseph travelled and spoke to many audiences. These photographs were taken when he lectured at the Seattle Theater on 20 November 1903. According to a reporter, Chief Joseph was eager to have his photograph taken by Curtis and made elaborate preparations before coming out for the session. He wanted to have his photograph made full-length, which would show off his high status clothing.

However, Curtis refused to take a full-length portrait and instead made a bust view of the chief both with and without his elaborate headdress. The photograph with the headdress was more documentary and fitted well with the ethnographic description of the Nez Perce in volume 8, while the photo without the headdress is more Pictorialist in style and appealed to Curtis's aesthetic goals. This latter image was published in his folio.

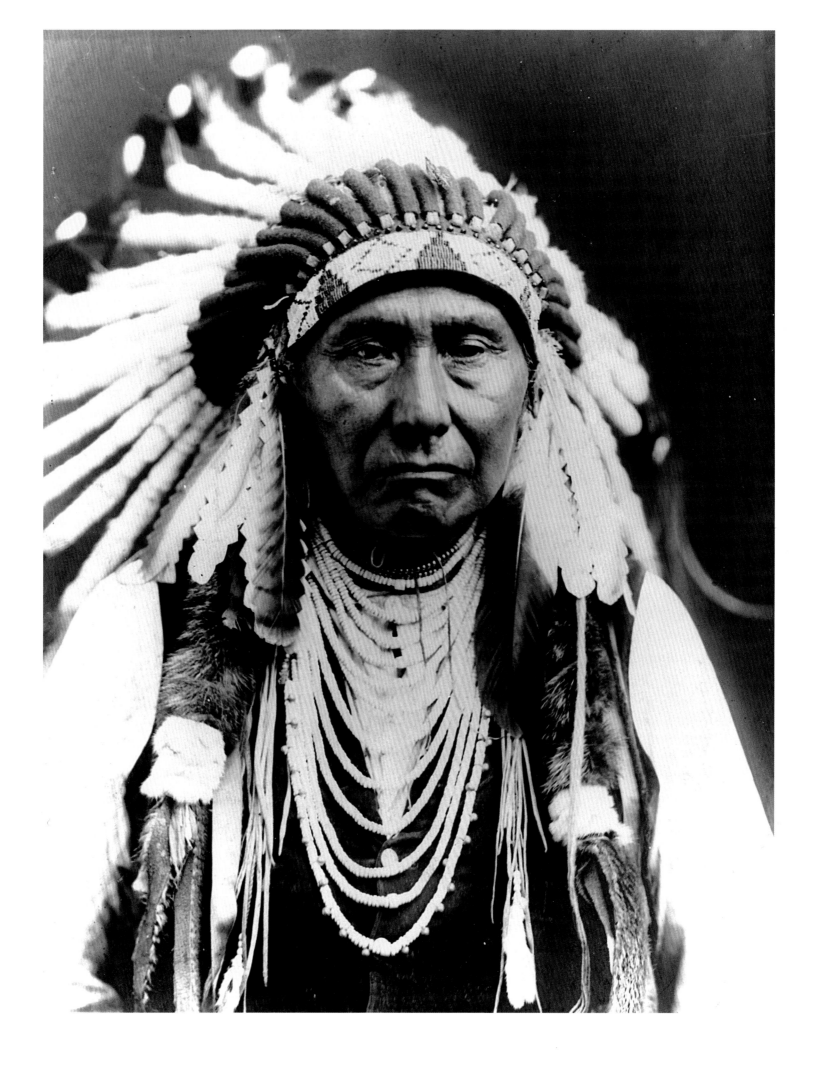

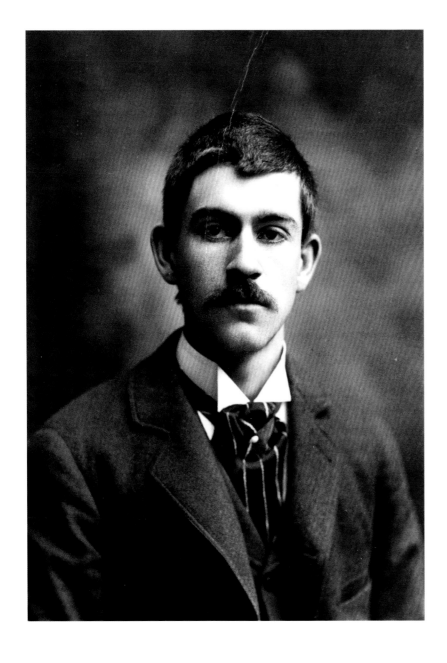

The young man (above) poses wearing a fine silk cravat, heavily starched button-on-wing collar and three-piece suit, all characteristic of the clothing of middle-class professional men at the turn of the twentieth century. His non-traditional hairline was probably the result of youthful self-styling. Kincaid was the entomologist on the 1899 Harriman Alaska Expedition, where he met Curtis. A professor of zoology at the University of Washington from 1901 to 1942, he helped revitalize Washington State's oyster industry. He also identified hundreds of plant and animal species: an earthworm, a clam, a shrimp and a flower all bear the name 'Kincaid'.

This well-dressed lady (right) wears an S-curve summer dress (the shape formed by a corset and exaggerated by the drape of the garment), with raised waist, open form bodice and sleeve detail characteristic of the latest French fashion of 1903. Large hats were also in vogue at that time. Mrs Burke's up-to-date style indicates her high social status. A Seattle businesswoman, socialite and philanthropist, in 1879 she had married Judge Thomas Burke, an important progressive civic leader in the city. These are examples of the many elegant portraits that made Curtis Seattle's foremost photographer of the social elite.

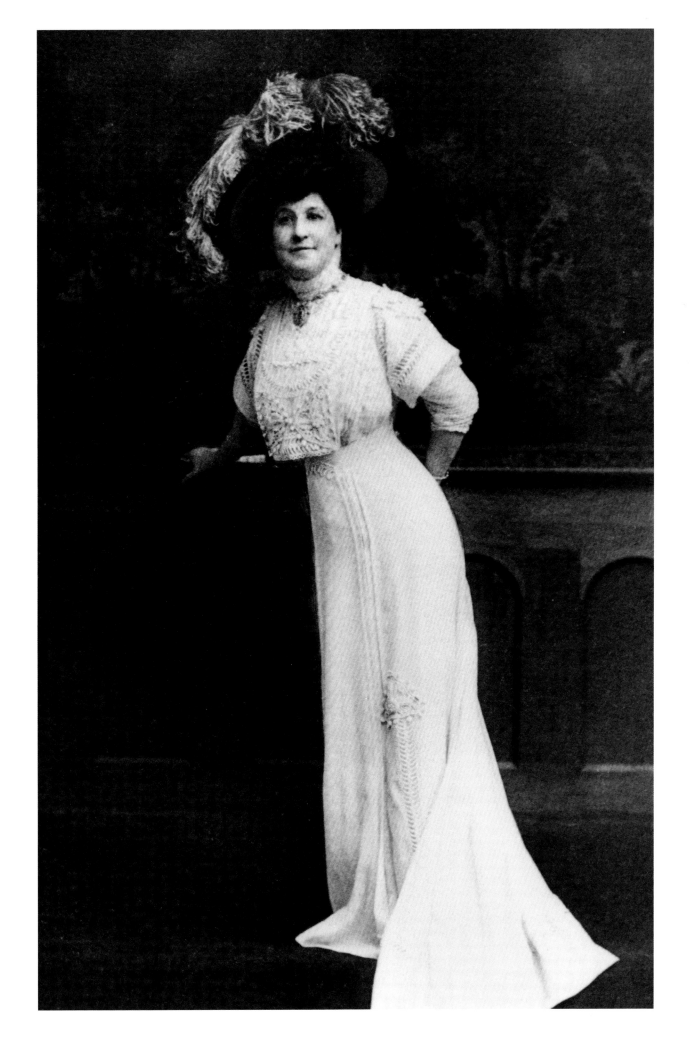

Zuñi Water Carriers,
before 1903

Curtis sold his images in a wide variety
of forms, including individual prints
in sepia tone and elegant platinum prints.
This popular photograph, made into
a postcard, was used for the tourist trade.
In producing this image Curtis portrayed
the women, whose names remain
unknown, shrouded in blankets to
heighten their mystery and exotic allure.
The Zuni (modern spelling) of the
Southwest culture area, located in
present-day western New Mexico, were
heavily influenced by traders and tourists.
The photograph displays both the women
and their wares — in this case the pottery
that was collected by tourists.

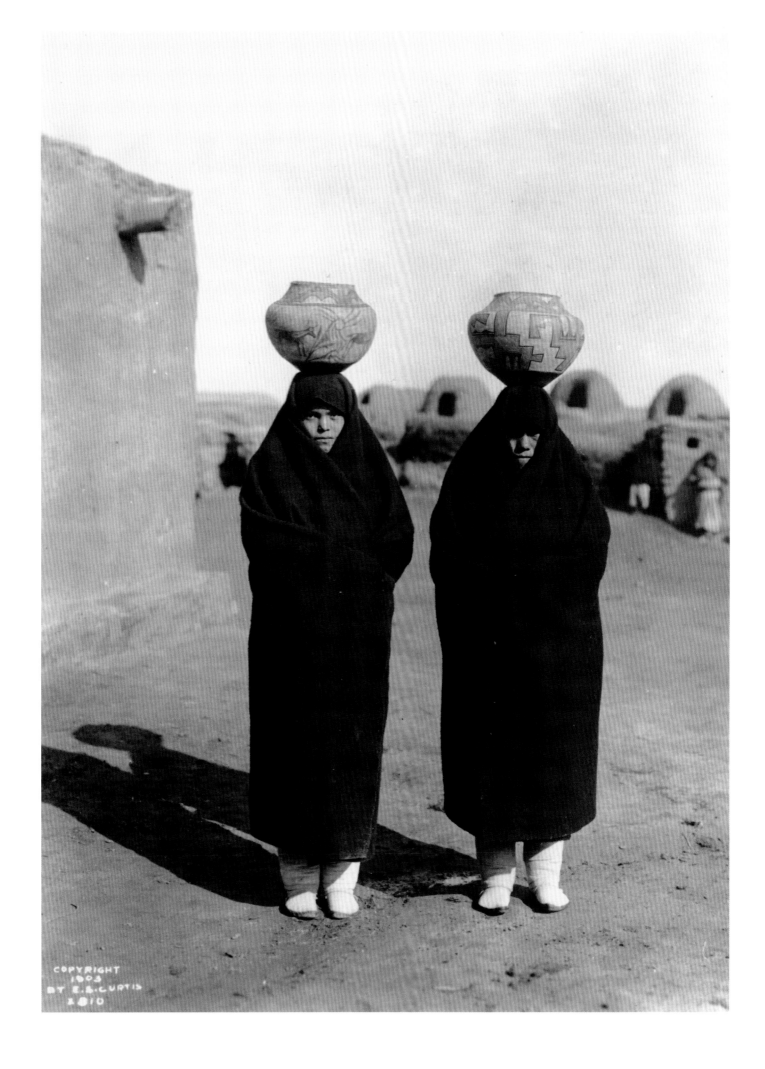

In this portrait a young woman wears multiple necklaces of silver and turquoise, some decorated with coins. Silversmithing was introduced during the Spanish period – the three centuries of Spanish contact that was effectively ended in 1821 with the revolt of Mexico and the withdrawal of Spanish troops and missions. The making of silver jewellery among the Zuni reached a peak in the twentieth century when women also became expert at stone cutting and mounting, skills formerly practised only by men. Clearly Native American by virtue of clothing, accessories and features, portraits like this are both ethnographic types and evocative images that convey a sense of the sitter's culture.

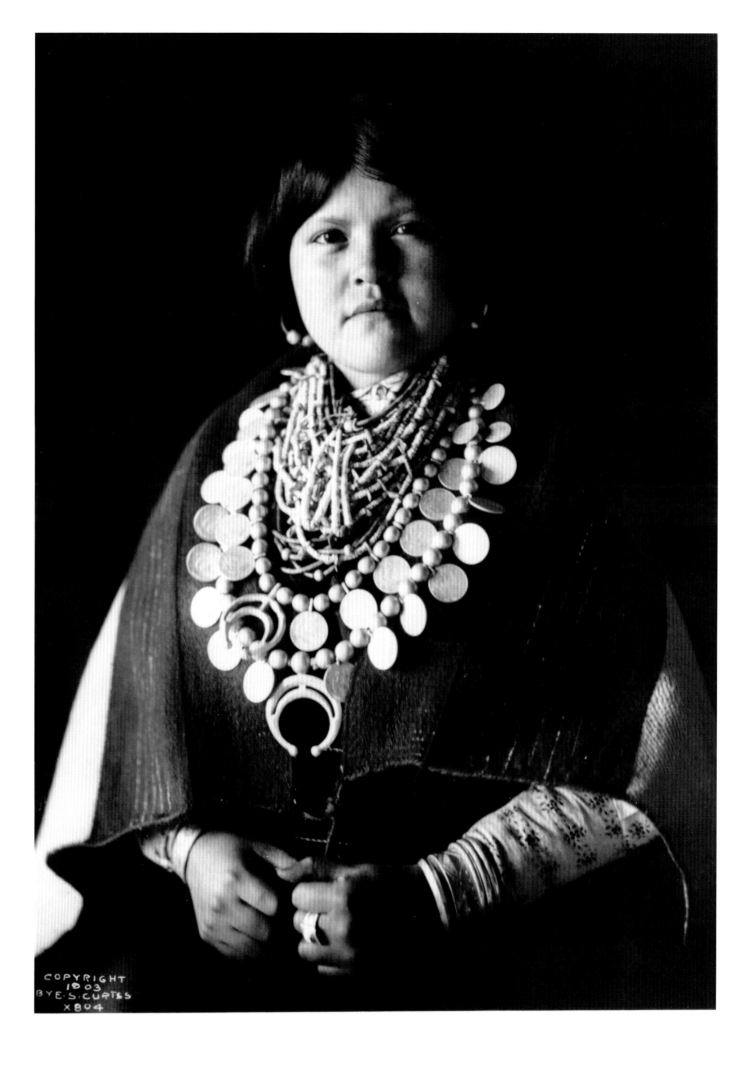

Jicarilla Maiden, 1904

'This pictures exceedingly well the typical Jicarilla woman's dress: a cape of deerskin, beaded ... and the hair fastened at each side of the head with a large knot of yarn or cloth' (volume I). The girl's clothing would also have included a broad belt of black leather, a deerskin skirt and legging-moccasins. The Jicarilla Apache are of the Southwest culture area located in northern New Mexico and southern Colorado and their traditional culture reflected a blend of influences. By the late-seventeenth century they had acquired a knowledge of horticulture from the Pueblo Indians. Men prepared the fields and dug the irrigation ditches, while women planted, hoed, weeded and harvested maize, beans, squash and other crops. From the Plains tribes they acquired the horse, which allowed them to travel to the Plains to hunt buffalo and develop their raiding techniques.

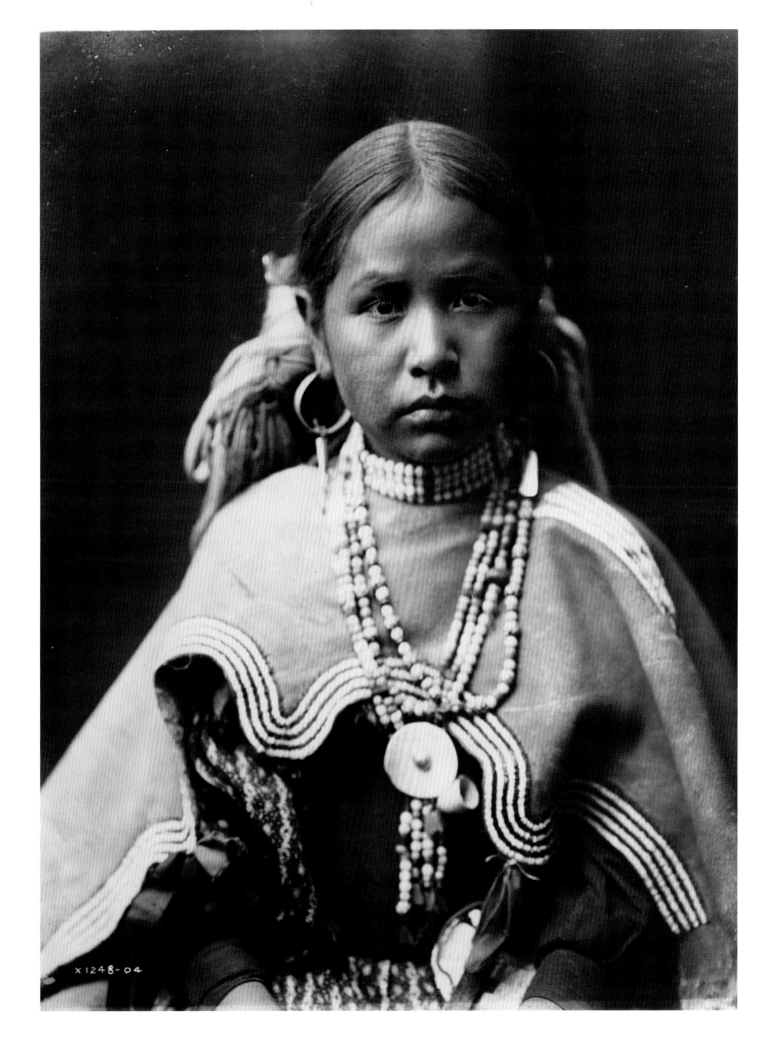

X1248-04

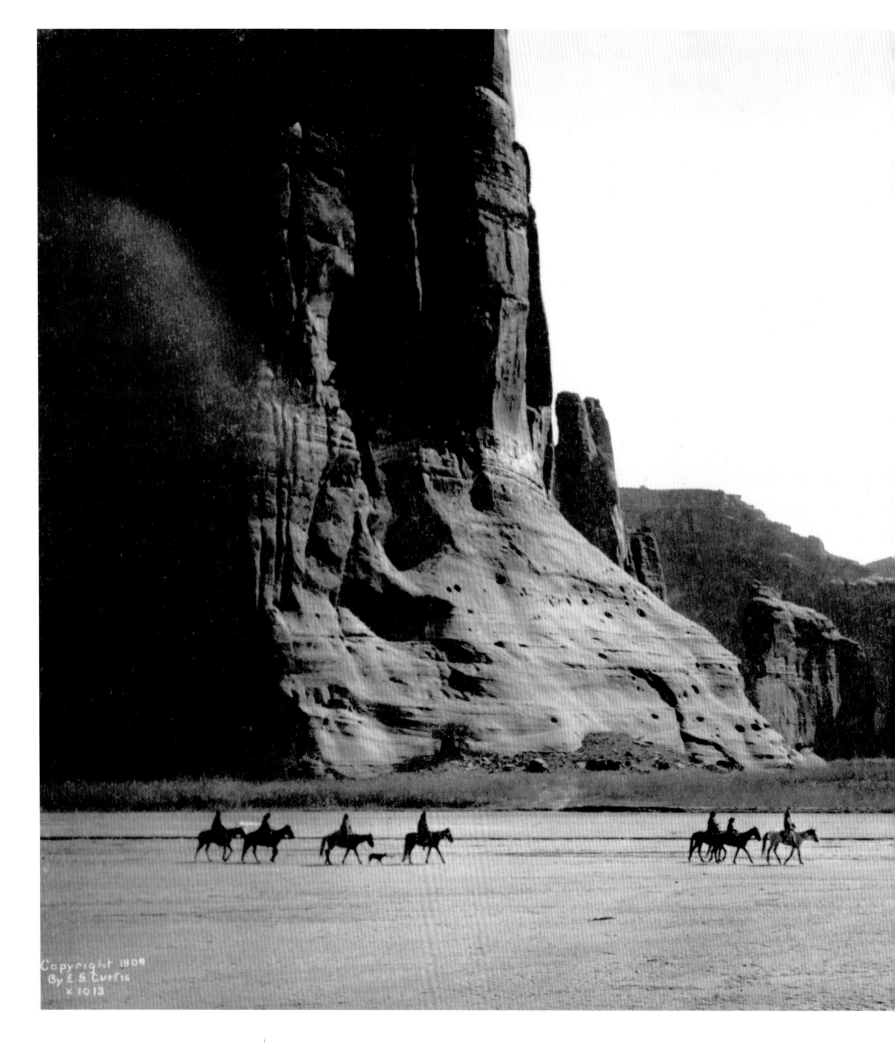

Copyright 1908
By E. S. Curtis
× 1013

Cañon de Chelly —
Navaho, before 1904

Cañon de Chelly, in northeastern
Arizona, lies at the heart of the territory
of the Navajo (modern spelling), one of
the largest groups in the Southwest
culture area. In the script for one of his
1911–12 'picture-musicales', Curtis
commented that this canyon is considered
'the Canyon of the Divine Ones. To the
Navaho it is the rift in the earth from
which the gods emerged to direct and
teach men. The echoing walls send back
voices from those who no longer walk the
earth, as it is not alone the home of the
gods, but of the prehistoric people.'
The Navajo presence in this powerful
landscape is dwarfed by the expanse of
time represented by the canyon walls.

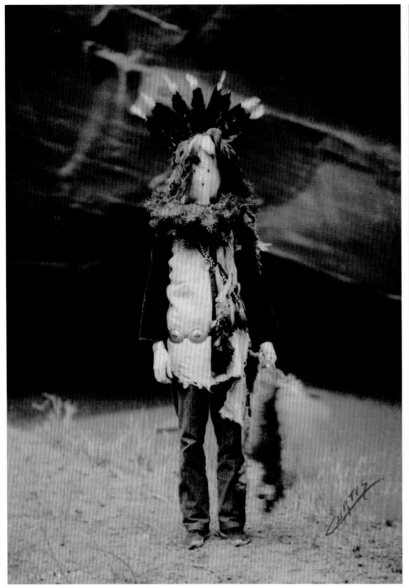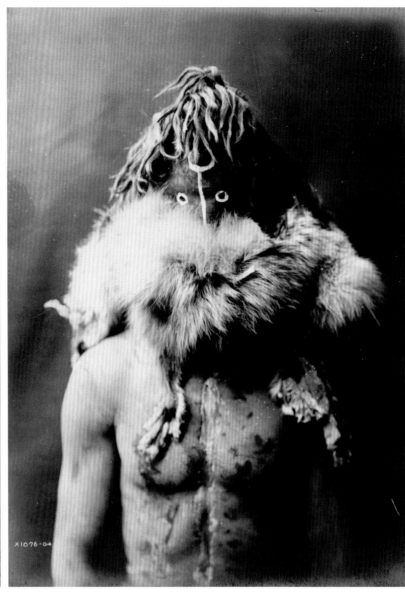

Above left: Haschélti –
Navaho, 1904
Above right: Haschézhíni –
Navaho, 1904
Opposite: Tónenili –
Navaho, 1904

The Holy People of the Navajo are
ceremonial beings of great power, and
therefore dangerous. They can take
anthropomorphic form as impersonated
here: Haschélti (the Talking God),
Haschézhíni (the Fire God) and Tónenili
(the Rain God). The Navajo ceremonial
system, which is both orderly and all-
inclusive, provides the mechanism for
coping with the dangers and uncertainties
of the world. Navajos believe that

improper conduct leads to the disturbance
of the normal harmony or balance among
elements in the universe, which in turn
leads to illness. Curtis wrote that the
most elaborate ceremonies are conducted
'between the first frost of autumn and
the second moon following the winter
solstice' (volume I). Curtis, however, was
with the Navajo only during the spring of
1904 and so these pictures were not taken
during actual ceremonial performances.

Curtis recruited various individuals,
including the sons of a non-Navajo
trader at Chinle, Charlie and Sam Day,
to re-create the costumes of the masked
Holy People and to pose for him in them.
The Talking God, shown above left, was
one of the most important figures in
Navajo ceremonies. Today, the gods
are known by the names Haashch'ééłti'í,
Haashch'ééshzhiní and Tó Neinilii.

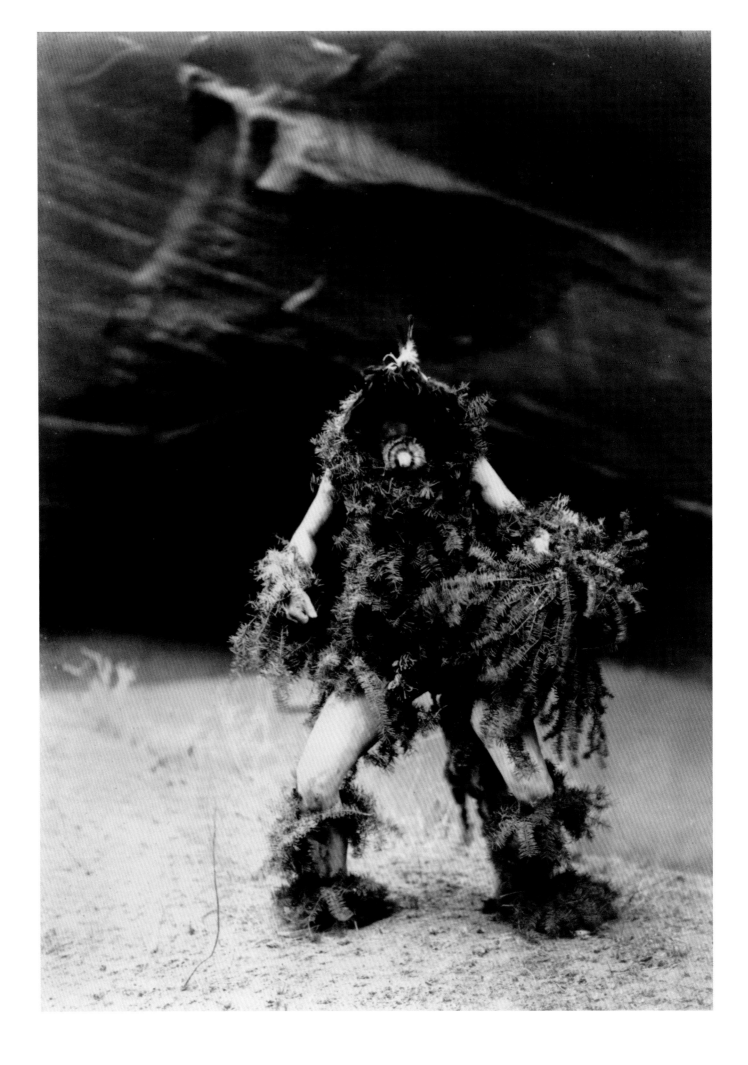

The Vanishing Race –
Navaho, 1904

'The thought which this picture is meant
to convey is that the Indians as a race,
already shorn of their tribal strength and
stripped of their primitive dress, are
passing into the darkness of an unknown
future. Feeling that the picture expresses
so much of the thought that inspired
the entire work, the author has chosen
it as the first of the series' (volume I).
This hauntingly graphic, seminal image
has been reproduced in almost every
publication dealing with Curtis's work.
He himself used it in lectures and in his
'picture-musicales'. Following typical
Pictorialist aesthetics, this print was
heavily manipulated during processing to
create the shadows, the vegetation around
the mounted men and the light in the
lower sky towards which the men ride.

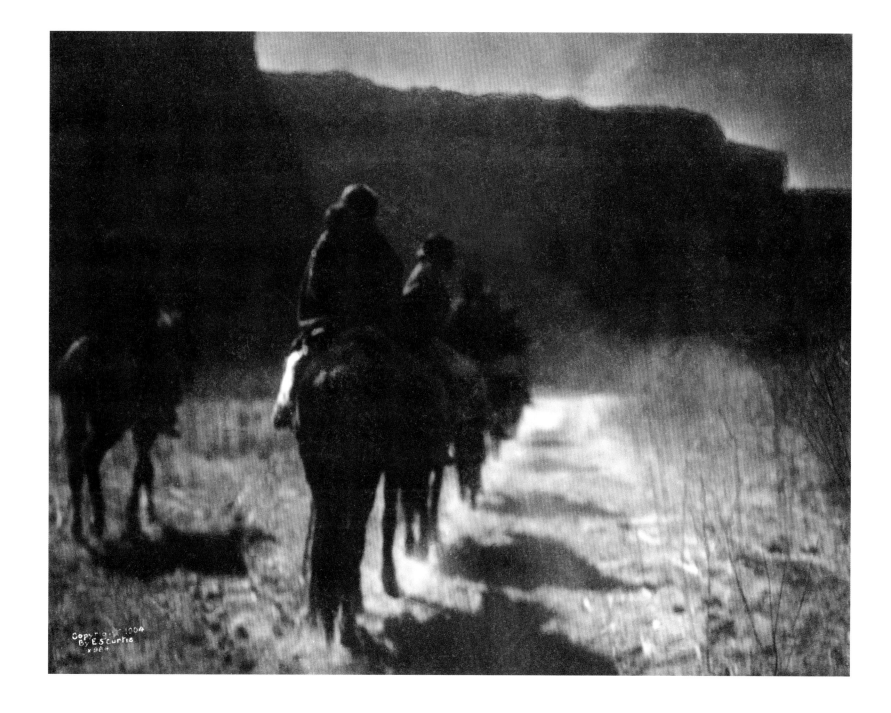

Acoma Water Carriers, 1904

A Pueblo is a community where tribes such as the Acoma and the Hopi (pages 59, 61) live. It can also refer to the dwelling structures themselves, known as 'pueblos.' The Acoma Pueblo is in the Southwest culture area, west of Albuquerque, New Mexico. The village is located on a high mesa in an area made up of mesas, deep-rimmed valleys, arroyos and rolling hills. The Pueblo is one of the oldest continuously inhabited communities in America and has been dated back at least a thousand years. The Pueblo's water supply comes from small cisterns in the rock filled by rainfall. As a reserve supply, there are also two large, deeper reservoirs, one fed by a small spring. This picture shows a group of women posed next to one of the cisterns of clear water, which reflects the rocks around them, and depicts them as totally at one with the stark, grand landscape.

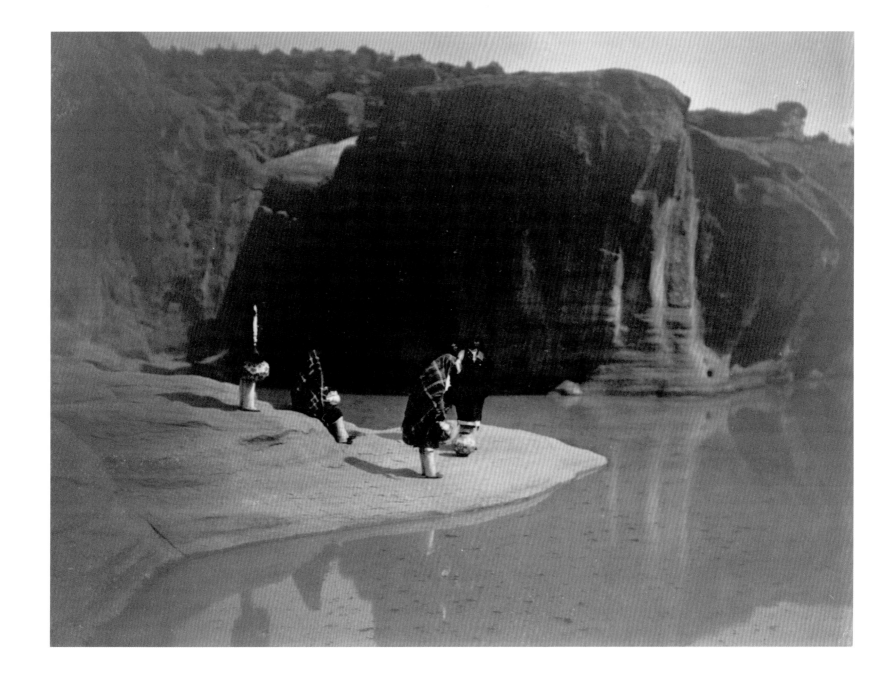

An Oasis in the Bad Lands, before 1905

This photograph shows Red Hawk, a Teton Sioux of the Oglala group, watering his horse. The Sioux were a people of the Plains culture area in southern South Dakota. According to Edmond S. Meany, a newspaper reporter who helped Curtis collect and write the historical material on the Teton Sioux for volume 3 of *The North American Indian*, Red Hawk was Curtis's principal guide during his fieldwork in the badlands of South Dakota. Red Hawk was a seasoned warrior who had, 'Engaged in twenty battles, many with troops, among them the Custer fight of 1876.' This evocative image shows Red Hawk posed with the grasslands as a background. The darkened sky and barely discernible figure seen through a soft focus, fog-like atmosphere is one of Curtis's signature styles and evokes a oneness with the natural surroundings. The title of the image is also evocative: by definition an oasis offers relief. Was Curtis attempting to suggest the attitude of the venerable Sioux warrior at this time? Although he was dressed in traditional clothes with full feather bonnet, Red Hawk was no longer able to pursue the old way of life. Curtis posed his subject to depict a romantic stereotype, but in doing so he may have been relieving, though only temporarily, the boredom of his subject.

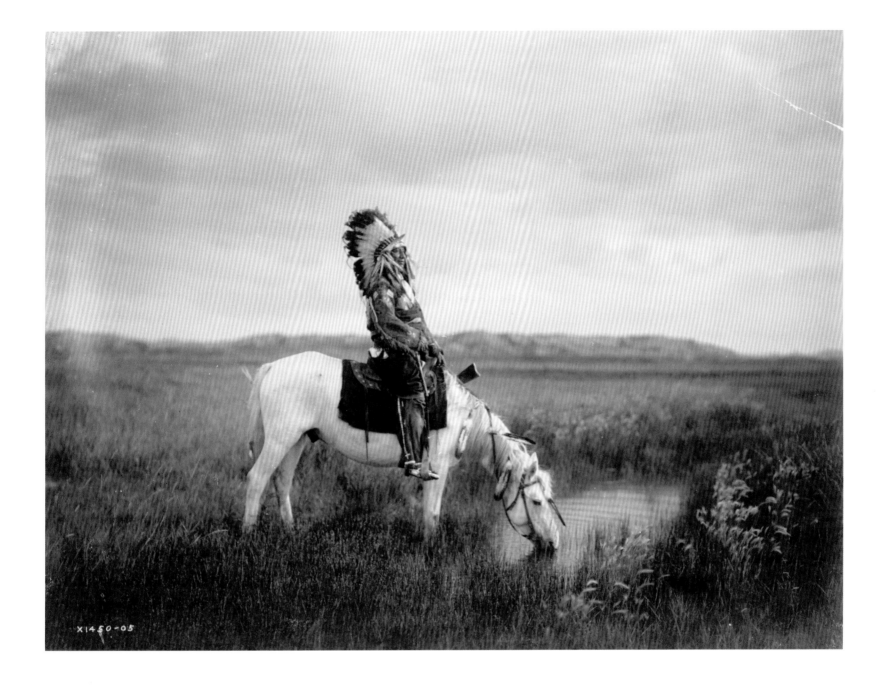

Geronimo, 1905

There are seven recognized Apachean-speaking tribes of the Southwest culture area. Geronimo was a leader of the Chiricahua Apache, famous for his war exploits. He held out against US Army troops until 1886, when he was taken prisoner and sent first to Florida and finally to Fort Sill, Oklahoma. In an exhibition of some of his photographs in 1906 Curtis used this image and captioned it: 'Formerly the war spirit of the Apaches, now a prisoner of war in the Indian territory.' This photograph was not, however, used in Curtis's twenty-volume series. It appears to have been made at the same time as the photograph of Geronimo that appears as plate 2 in volume 1 of Curtis's folio, which depicts a wizened, old man as a perfect representation of the 'vanishing race'. Both images were made in Carlisle, Pennsylvania, where Curtis and Geronimo were on the day before the inauguration of President Theodore Roosevelt in March 1905. Geronimo was one of the Native Americans who had been invited to take part in the inaugural parade in Washington, DC. He is wearing one of his ceremonial headdresses and a wool blanket, and holds a lance, as he did during the parade.

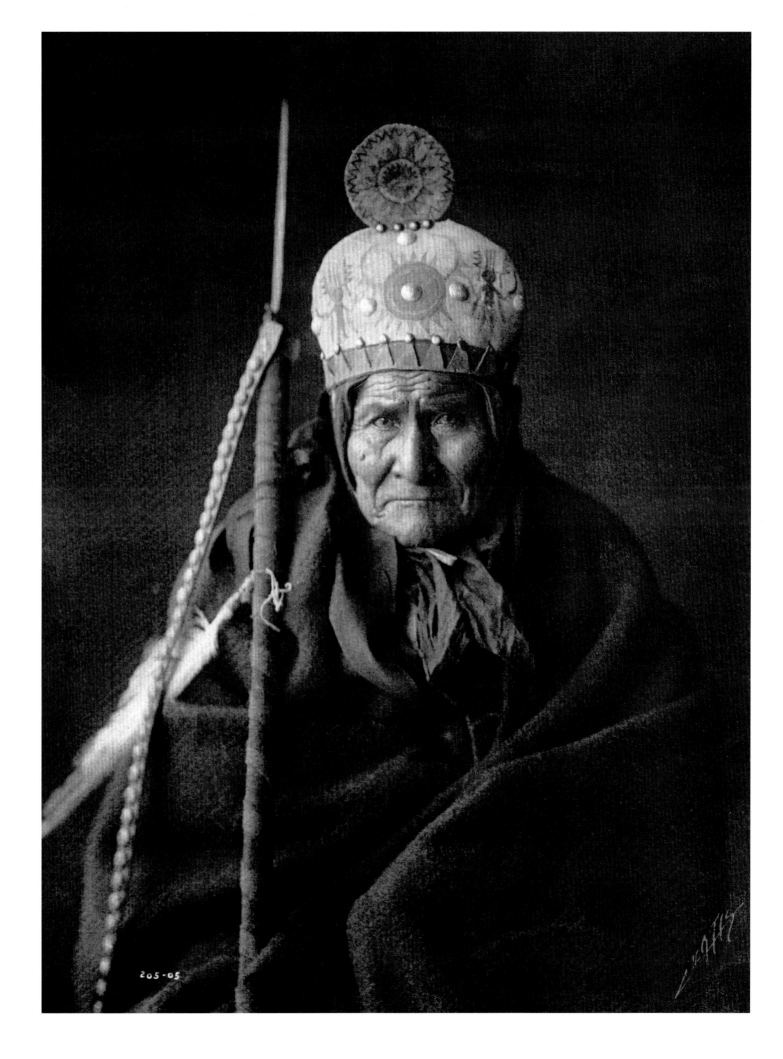

Frost Moving (also known as Oyégi-Anyĕ
according to Curtis), governor of Santa
Clara Pueblo, is shown holding two
silver-headed canes of office. One cane
is incised with a cross and is of Spanish
origin and the other, more elaborately
engraved, was given to an earlier governor
in 1863 by Abraham Lincoln. The Santa
Clara Pueblo was located on the west
bank of the Rio Grande in northern New
Mexico, in the Southwest culture area.

The Pueblo was influenced by three
Euro-American cultures, Spanish,
Mexican and Anglo-American, and their
political organization consists of a blend
of these systems. Their governor (an
office derived from the Spanish period)
is the individual who deals with the
outside world. Frost Moving is wearing
what appears to be a Theodore Roosevelt
button on his lapel, an example of his
involvement in affairs outside the Pueblo.

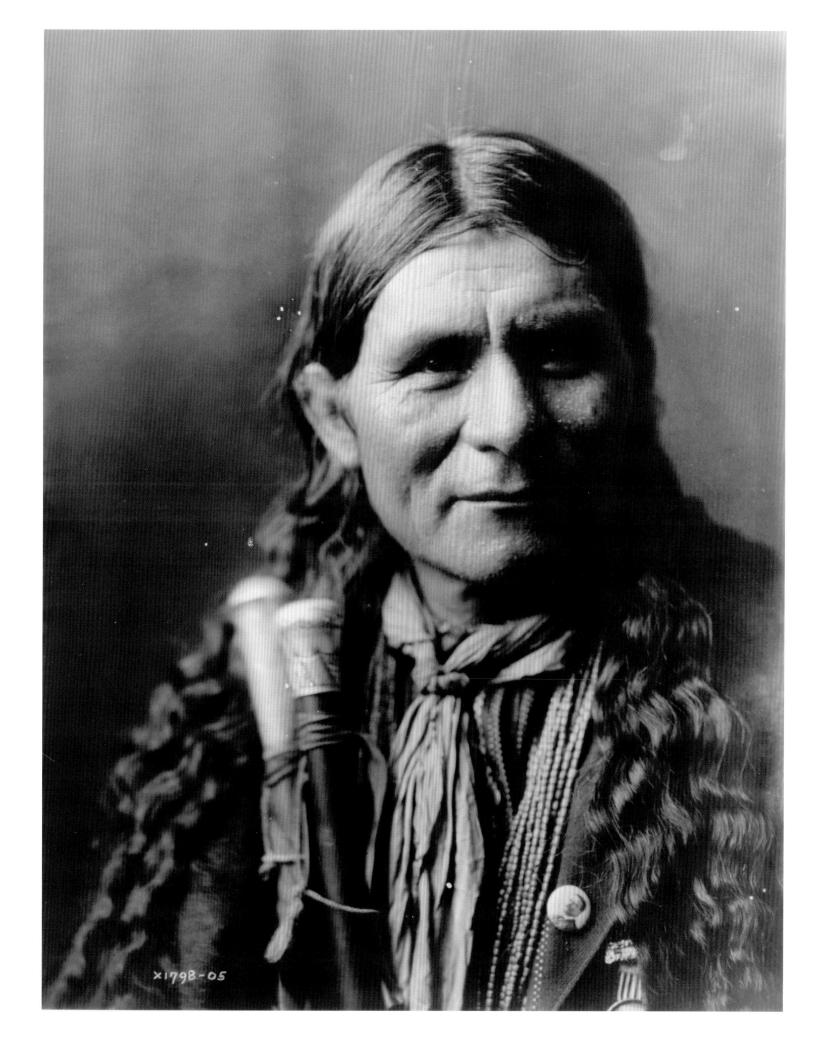

Joseph Dead Feast Lodge –
Nez Percé, 1905

The winter homes of the Nez Perce were traditionally mat-covered, double lean-to longhouses typical of those found throughout the Plateau culture area. Bigger structures were built for ceremonial occasions. The largest longhouse that Curtis saw during his fieldwork for volume 8 was this one, which was made of canvas and erected for the memorial feast of Chief Joseph (pages 30, 31) who died on 21 September 1904. The feast itself, arranged by Joseph's relatives, was held in June 1905 after his reburial at Nespelem, Washington State. The ceremonial structure was 100 feet in length and 20 feet in width, and contained 10 separate fires. Such a composite lodge could accommodate a large number of guests. After the feast was arranged, Joseph's personal property was given away: such items as horses, clothes, and hunting or fishing equipment would be presented to the men, while beaded bags, robes and cooking equipment were presented to the women. Usually, everyone attending such a feast received a gift. It took two days to distribute his wealthy estate.

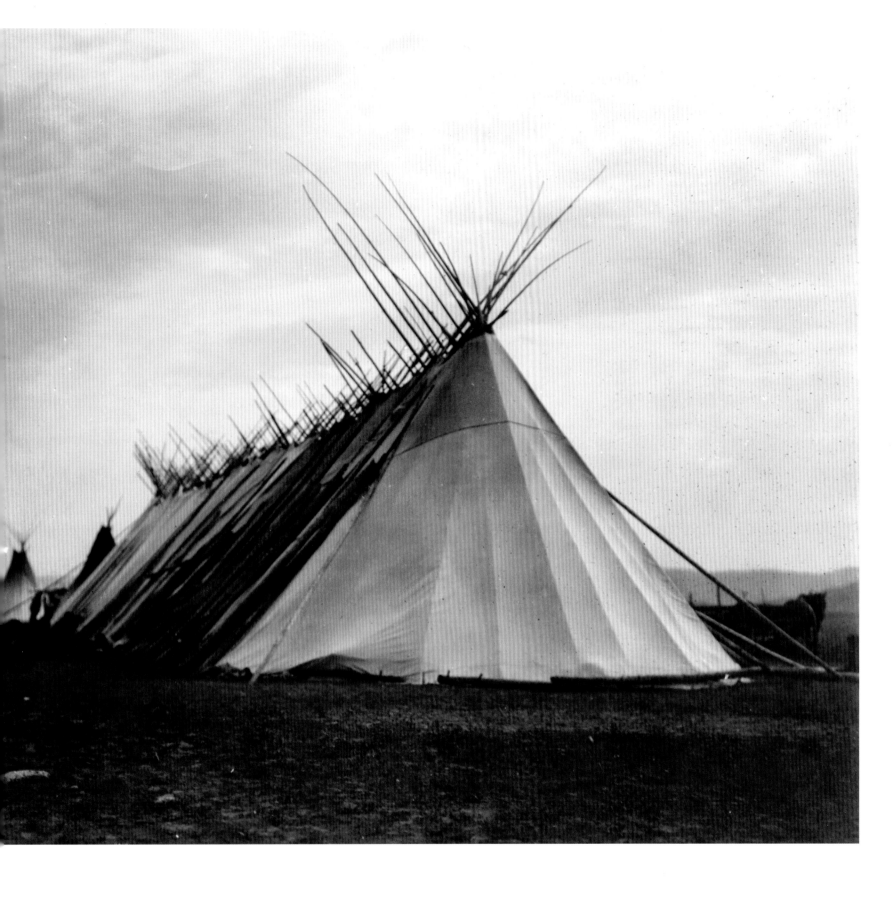

Curtis, intent on emphasizing the traditional culture of Native American subjects, was at pains to note that the 'primitive dress of the men was deerskin shirt, leggings, and moccasins. They were never without the loin cloth, the one absolutely necessary feature of Indian clothing' (volume 1). However, it is clear that this man was not dressed in traditional fabrics, although he is wearing the traditional loin cloth and moccasins. When published, this image was cropped and the photographer's backdrop obscured. According to some critics, the cropping compressed the subject, forcing him towards the viewer so that his stance appears as a crouch, and makes him seem menacing. It is clear that 'reading' photographs can produce very subjective interpretations.

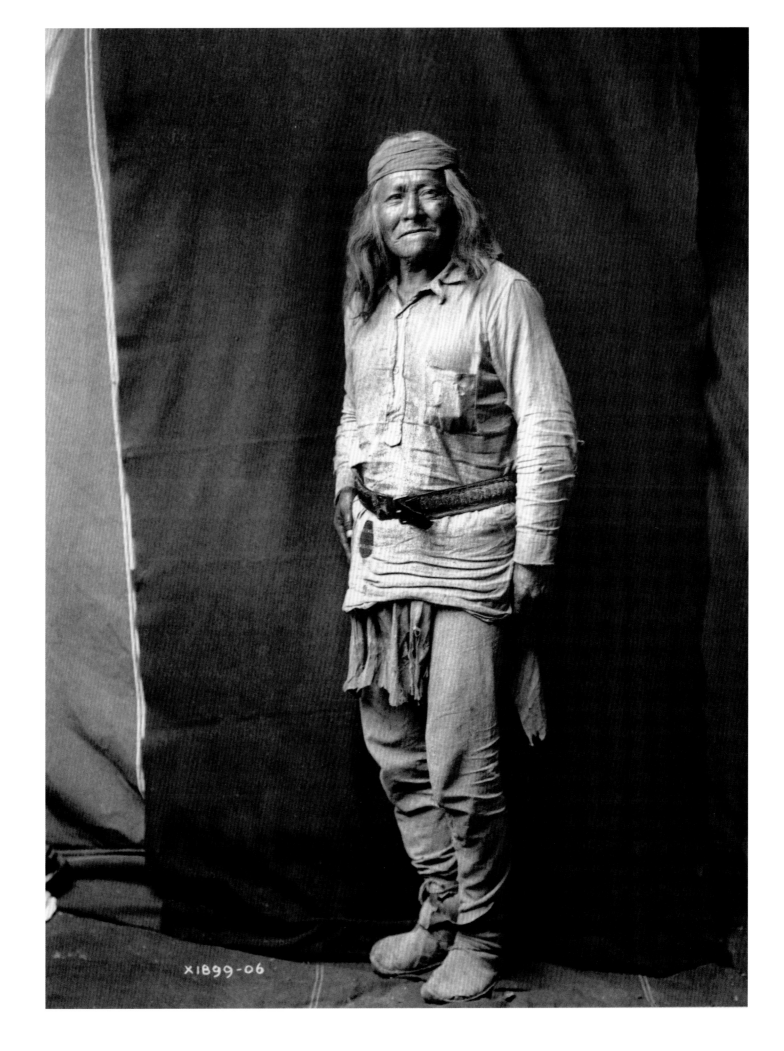

On the Housetop, 1906

Curtis photographed the four young women (in the top right) on at least four occasions at Walpi, one of the Hopi Pueblos located in the Southwest culture area in northern Arizona. In his published photographs the girls tend to have their backs to the camera, thereby remaining anonymous and emphasizing the exoticism of their dress and hairstyle. Curtis described this: 'Females part their hair in the middle from the forehead to the nape of the neck. Unmarried girls arrange it in a large whorl above each ear, a very distinctive style symbolic of the squash blossom; while married women have at each side of the face a shoulder-length club of hair wrapped from end to end with a long, dark blue, cotton string. The picturesque whorl fashion is so fast disappearing, at least in Walpi, that in three months' observation in the winter of 1911–12 only one girl was seen with hair so dressed except on ceremonial occasions' (volume 12). Two married women, with their shoulder-length hair, one holding a child, are seated in the bottom left.

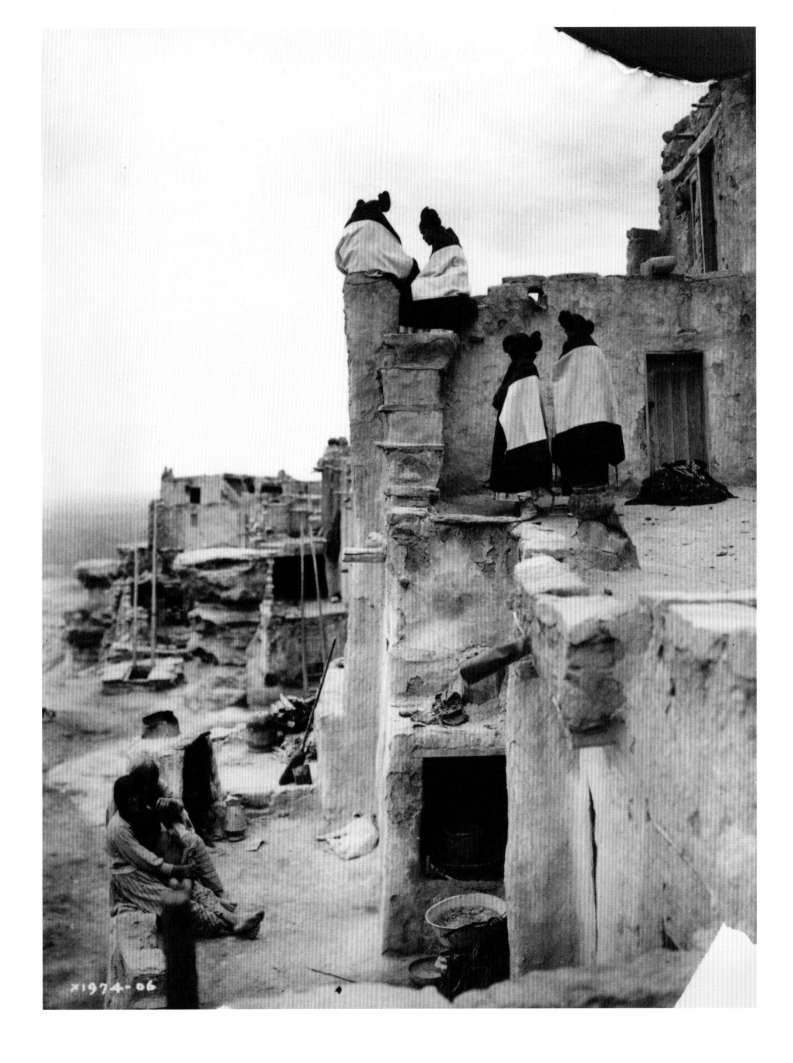

Grinding Meal, 1900–6

Four unmarried girls are demonstrating the grinding of corn meal (maize), probably at Walpi Pueblo. (The bins would have been filled with maize if the girls had actually been in the process of grinding.) Each Hopi house contains two to four grinding stones set in a wooden frame. These stones differ in their degree of coarseness, and the maize is ground successively in them by rubbing with a long stone until the desired fineness is reached. A flat basket, as seen in the foreground, is used to hold the ground maize. Most of the girls have their faces turned towards the stones, focusing the viewer's attention on the distinctive hairstyle that had so interested Curtis.

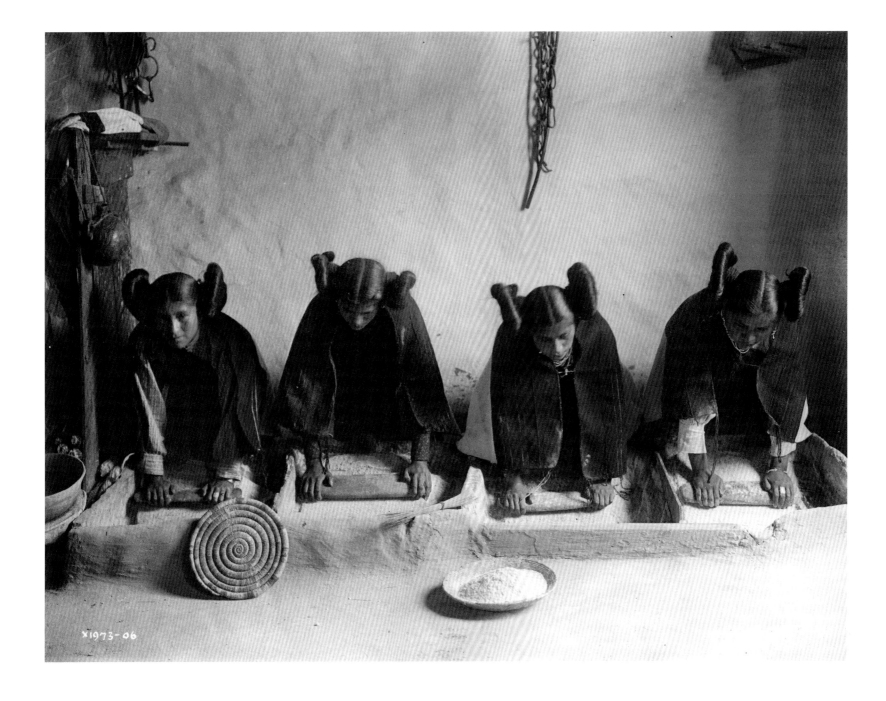

Ndee Sangochonh, c.1904–6

A Western Apache man from the White Mountain Apache group whose name, Sanigo nchon (modern spelling), is translated as 'lone bad man'. He wears a cap decorated with beadwork designs in the shape of a cross, symbolic of the four cardinal points, and a crescent moon, representing the eternal beginning at each ending. Such designs were worn by members of a religious movement among the Apache, lasting from about 1903 to

1907, called *daagodighá* ('they will be raised upward') which blended elements from both native and Christian religions. The followers of this movement believed that they would ascend into the sky when evil was eliminated from the world and that they would return to their homes to live prosperous lives. Later, the cross and crescent became insignia of yet another Apache religious movement, founded by Silas John Edwards in the 1920s.

In a composition characteristic of Curtis's *oeuvre*, Sanigo nchon looks squarely at the photographer's camera with a compelling directness.

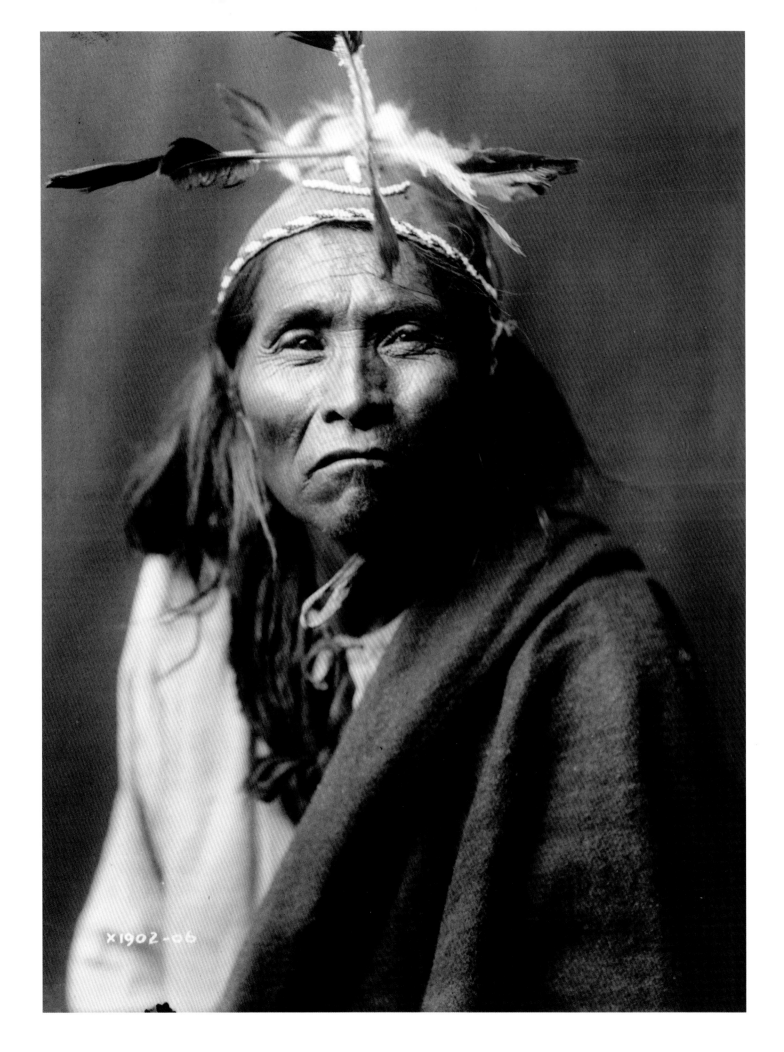

X1902-06

The Papago are a people of the Southwest culture area located in southern Arizona. Their desert environment was a marginal one, and out of necessity they supplemented horticulture with the gathering of wild food. '*Hánamh* is the Piman [the language of the Papago] name for the cholla cactus and its fruit … In gathering it they use rude tongs made from a split stick. After a basket is filled, the fruit is spread on the ground and brushed about with a small, stiff besom until the spines are worn off, or the spines are burned off in an open fire' (volume 2). The cholla buds, which ripened in May, were an important food source. Traditionally they were eaten boiled and salted, but in later periods they were also marinated in vinegar.

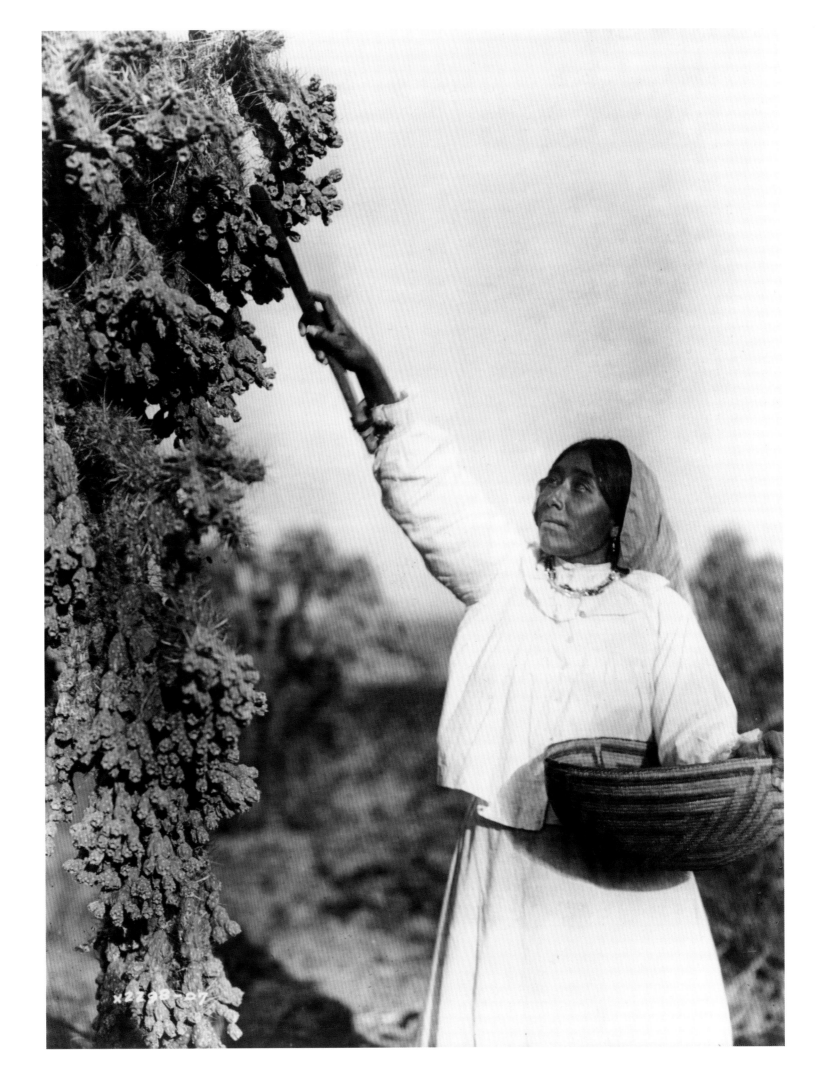

Hides of many animals including deer, elk, antelope, caribou, moose and mountain goat (as well as bison in earlier times) were prepared for use as clothing, bags and tepee coverings. This work was always done by women. Here a Kootenai (modern spelling) woman of the Plateau culture area (in northern Idaho and northwestern Montana) is making a hide more pliable by stretching it. The first stage in the process of turning raw hide into buckskin involved the removal of flesh and hair from the hide. Then it was stretched, soaked, scraped to reduce it to a uniform thickness, rubbed with fat and sometimes smoked. Only now was a hide supple and ready to be made into useful items. This picturesque image shows the woman as one with nature; the hard work that goes into preparing skins is not captured in the photograph.

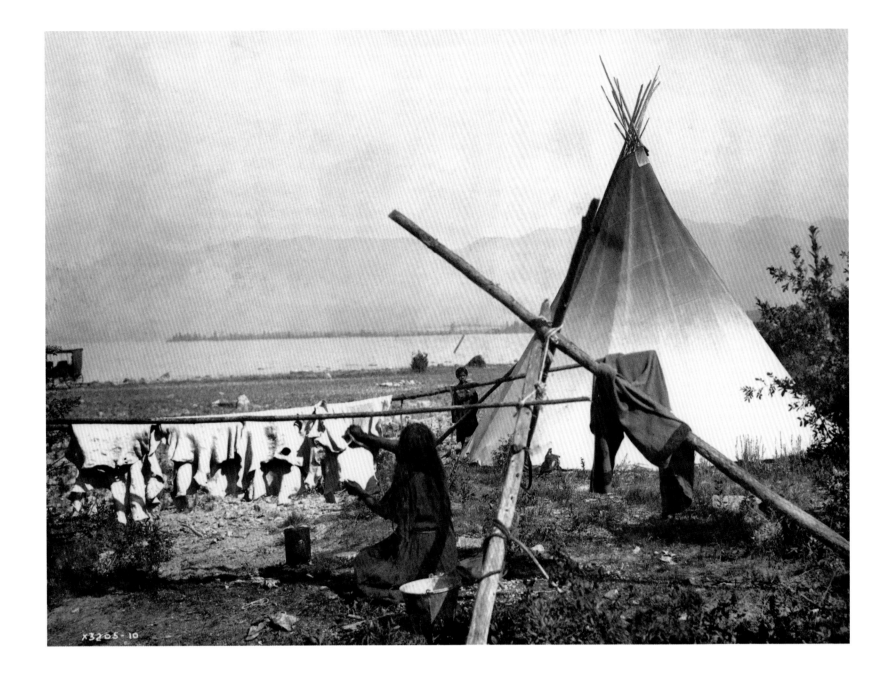

Atsina was the Blackfoot form of the name of the Gros Ventre, a Plains culture area people living in northern Montana. This image shows a Gros Ventre re-creation of a Crazy Dance ceremony. The initiates, who have received sacred powers and ceremonial knowledge, shoot arrows up into the air and remain motionless as the arrows fall around them. They were also required to walk on hot coals and to shoot arrows treated with medicine that induced paralysis in humans or animals. The 'Crazy Men' exhibited 'backward talk' and 'contrary' behaviour during the four-day, four-night ceremony, saying and doing the opposite of what was expected.

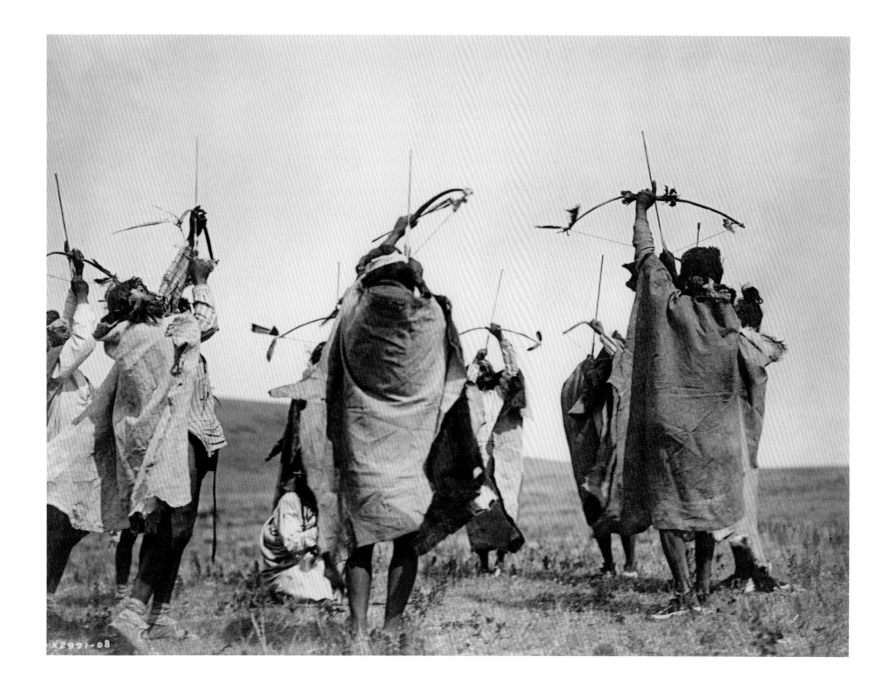

Arikara Man, *c*.1908

The Arikara were a people of the Plains culture area who were originally based in South Dakota before they came to the Fort Berthold Reservation in North Dakota. Traditionally, the men wore a lightweight buffalo robe or deerskin over their shoulders, even in the summer. By the time Curtis visited the Arikara traditional clothing was not in daily use, but because Curtis often emphasized the lifestyle of the past he pictured this man with a robe about him. This image was not used by Curtis in his twenty-volume series. It is, however, another good example of Curtis's style of portrait photography, presenting a powerful image of a face. One of Curtis's goals, as he stated in an article in 1914, was to create documents of 'the people and their homeland – a picture that will show the soul of the people'. This man's strong features and his steady gaze over the photographer's shoulder, evoke a statement of his absolute presence, of inner strength, and suggest perhaps a glimpse into his soul.

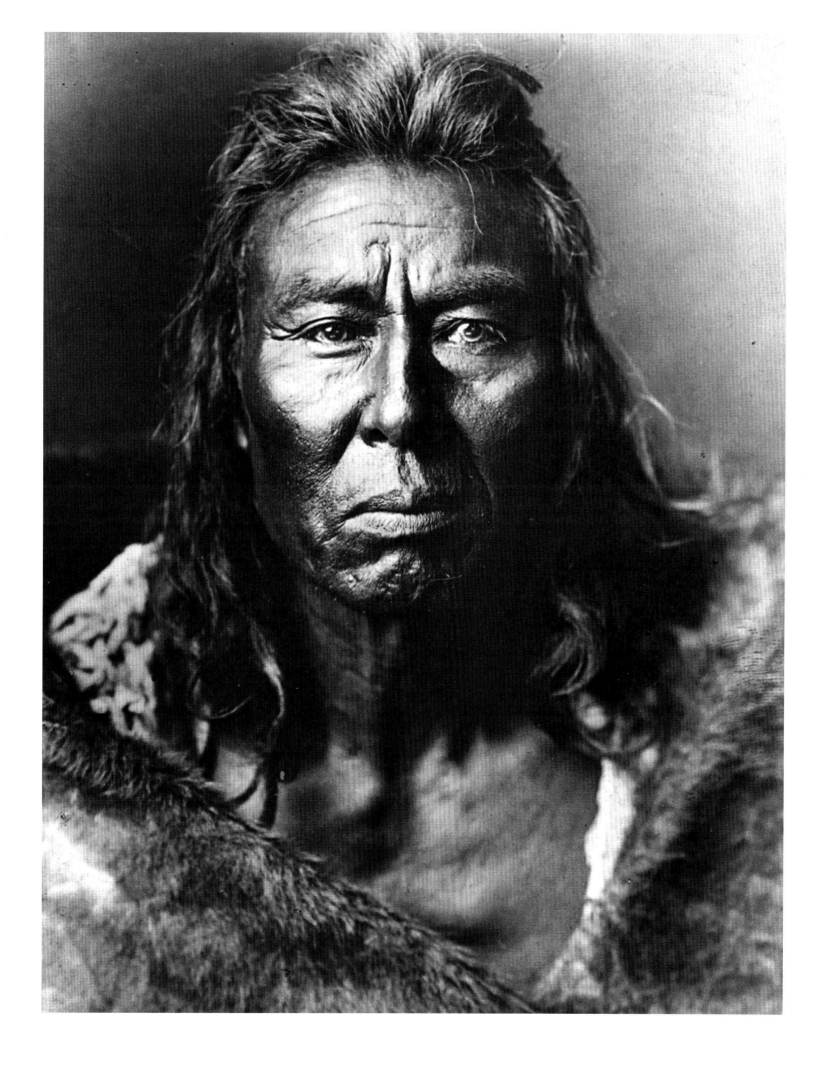

Arikara Medicine Lodge, 1908

The Medicine Lodge was the ceremonial
centre of every village of the Arikara.
It was constructed in the same manner
as Arikara homes, but was much larger,
accommodating as many as five hundred
people. Circular earth lodges were built
on a foundation of posts covered by
rafters and walls, over which were layers
of mats, brush and sod. The interior
had a central fireplace around which
ceremonial activities occurred. The
sacred cedar tree appears on the right
in this image, which depicts one of the
societies engaged in a ritual. 'Societies'
were groups that often cut across village
organization and had their own dress,
ceremonial paraphernalia, dances and
songs. This photograph is probably of
the Beaver Creek Medicine Lodge,
on the south side of the Missouri River
on the Fort Berthold Reservation in
North Dakota.

x2861-08

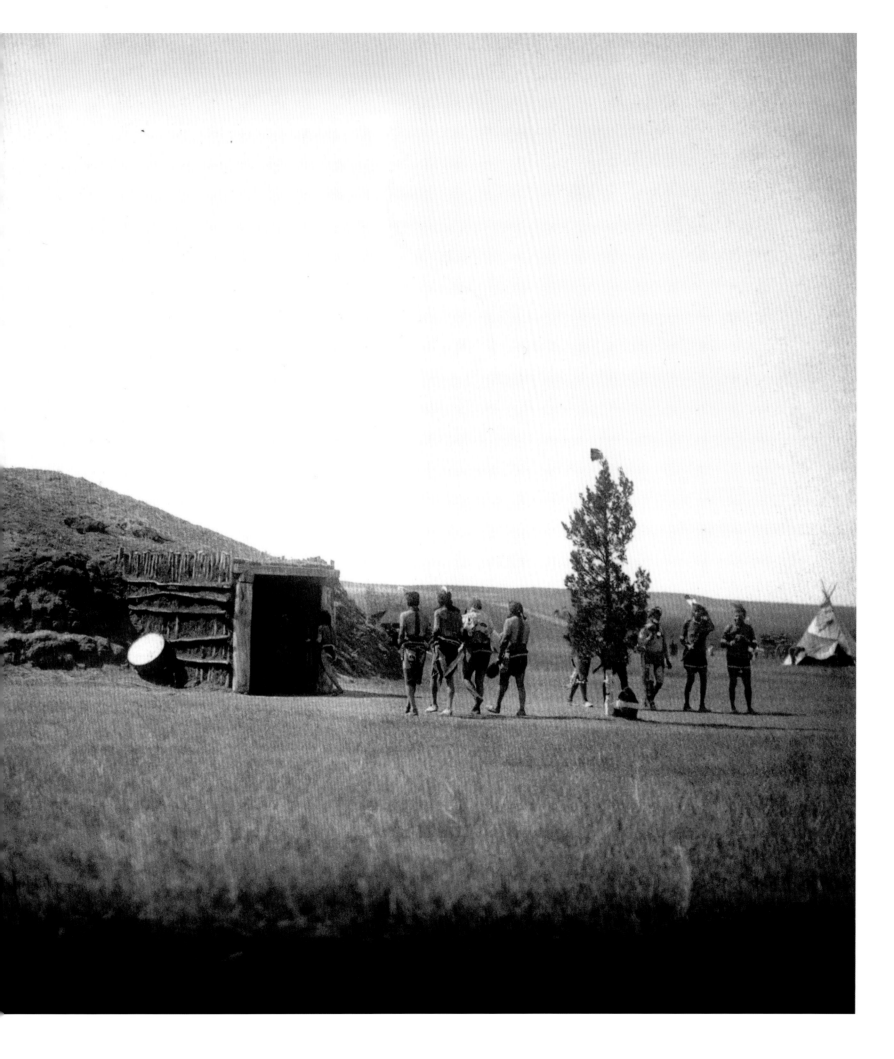

Wishham Bride, 1909

This portrait is of Dorothy George, a Wishram (modern spelling) woman from the Plateau culture area located along the Columbia River, northern Oregon and southern Washington State. She is dressed in clothing worn on special occasions between puberty and marriage, when the display of wealth was usual. She wears a necklace of clamshell wampum and other items obtained through the Columbia River trade network, including dentalium shell and olivella shell earrings and a headdress that incorporates shells, glass beads and Chinese coins. Wedding veils such as this were worn by Wishram girls at their marriage ceremonies. The rest of her costume – a beaded deerskin dress and belt – are similar to those worn throughout the Plateau and Plains culture areas. Marriage negotiations were initiated by the bridegroom's family and gifts were formally exchanged between the two families when the match was arranged. Feasts and the exchange of additional valuable gifts validated the marriage.

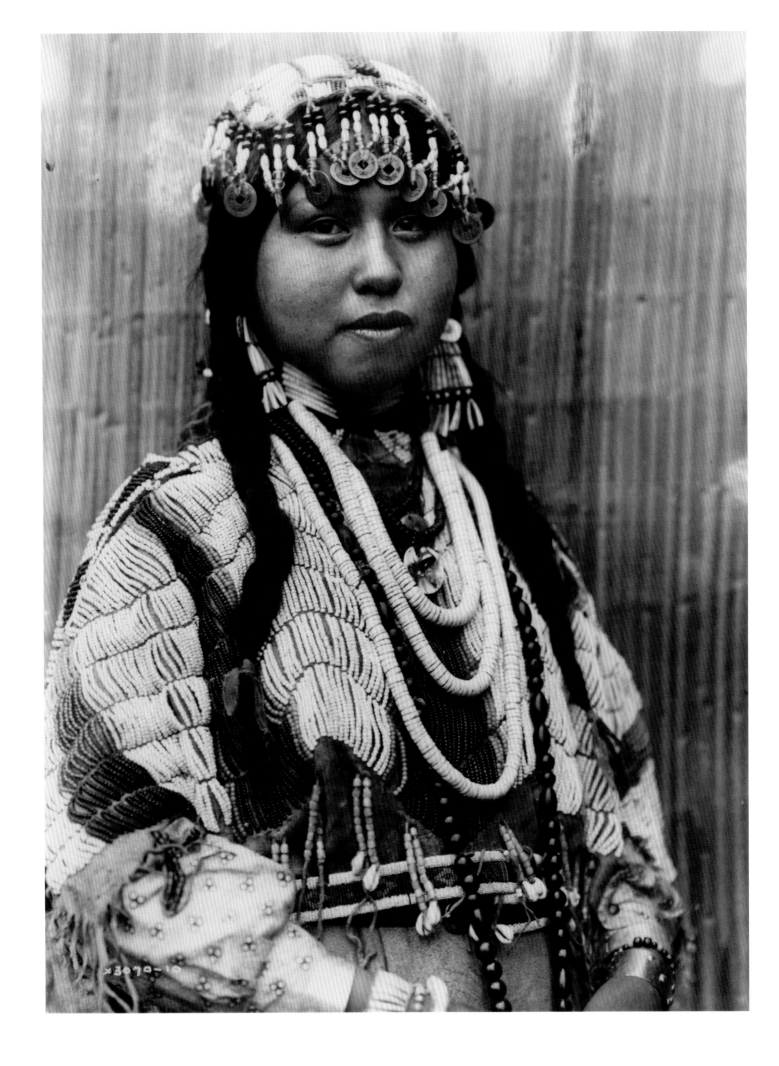

Pounding Fish – Wishham, 1909 Women preserved surplus fish by filleting, wind-drying and pounding them into a thick, powdery meal that was then dried on a reed mat (seen here in the background) to absorb the excess oil. Salmon pemmican, called 'sugar salmon' because of its texture, was packed in bags or baskets for winter storage and for trade. Curtis photographed this Wishram woman demonstrating the method of pounding dried fish using a wooden pestle and mortar that was also used for grinding berries and roots. This posed picture is one that shows how grinding would be done, but the absence of the ground fish in the mortar and on her dress is evident. Curtis often posed his subjects to achieve ethnographically interesting, but also aesthetically pleasing, portraits.

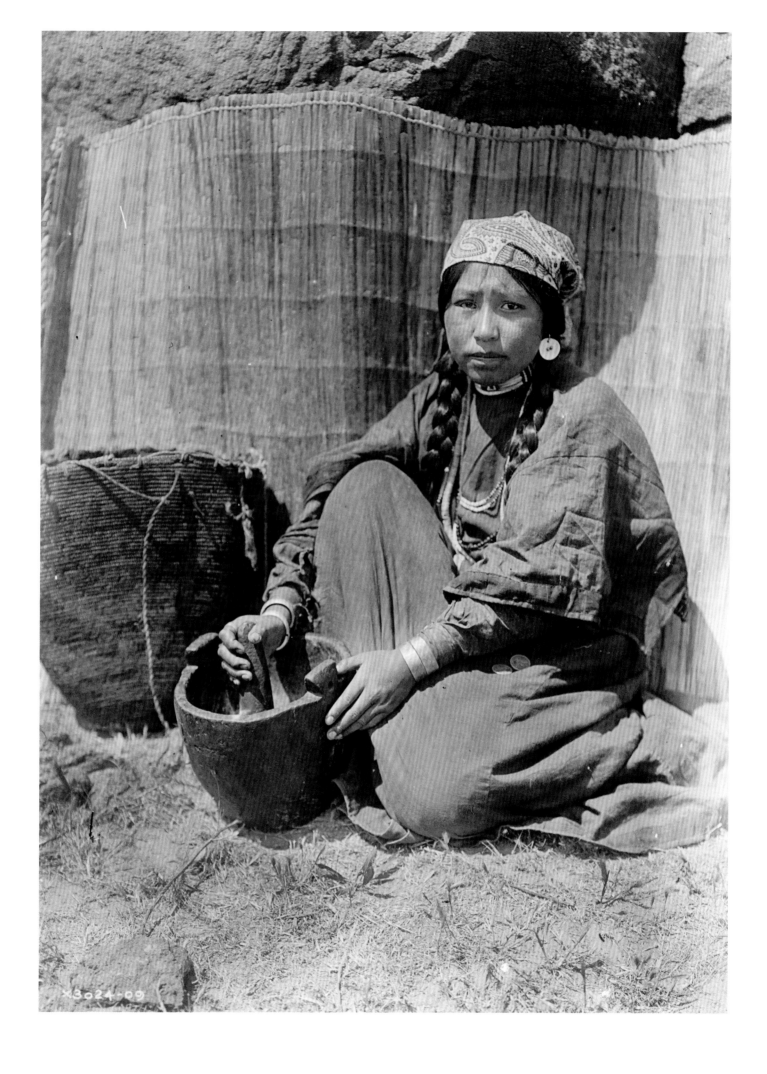

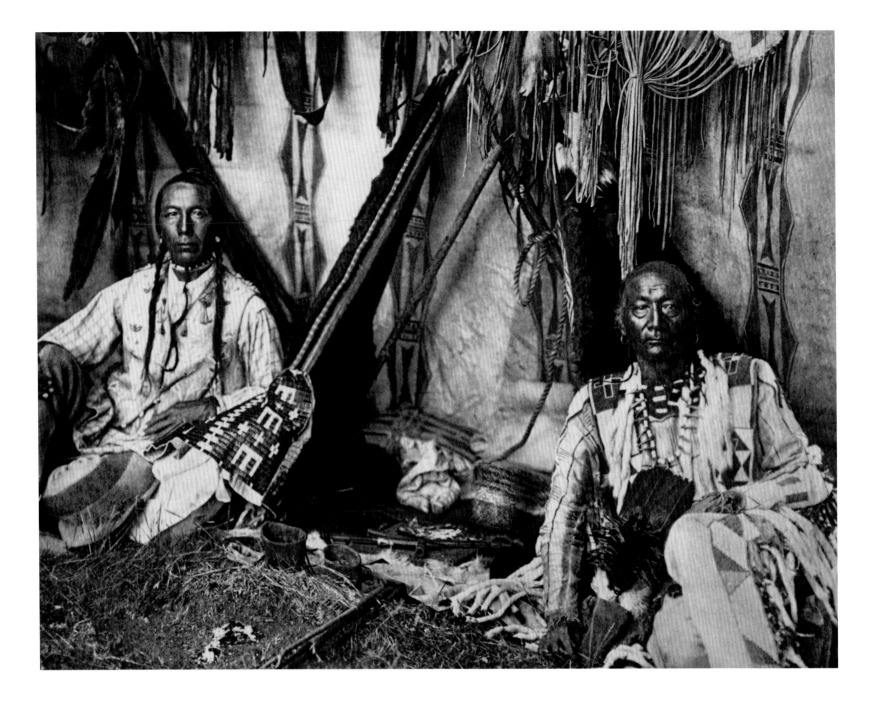

In a Piegan Lodge,
before 1910

Left: published retouched version
Right: unretouched original print

This photograph is of Southern Piegan
tribespeople and was taken on the
Blackfeet Reservation in Montana.
Curtis wrote of the published image:
'Little Plume with his son Yellow Kidney
... In a prominent place [in the centre
between the men] lie the ever-present
pipe and its accessories on the tobacco

cutting-board' (volume 6). By looking
at these two pictures, first published
together in 1982, it becomes evident that
an object – now revealed to be a clock –
between the two men was removed when
the image was made into a gravure for
publication in *The North American Indian*
(left). Some critics have claimed that this
was an attempt by Curtis to remove signs
of Euro-American contact, but there is
other evidence of such influence in the

picture, such as the machine-made rope
and the manufactured cloth shirt and
woollen leggings (possibly made from a
Hudson Bay Company blanket) worn by
the younger man, which Curtis did not
attempt to disguise.

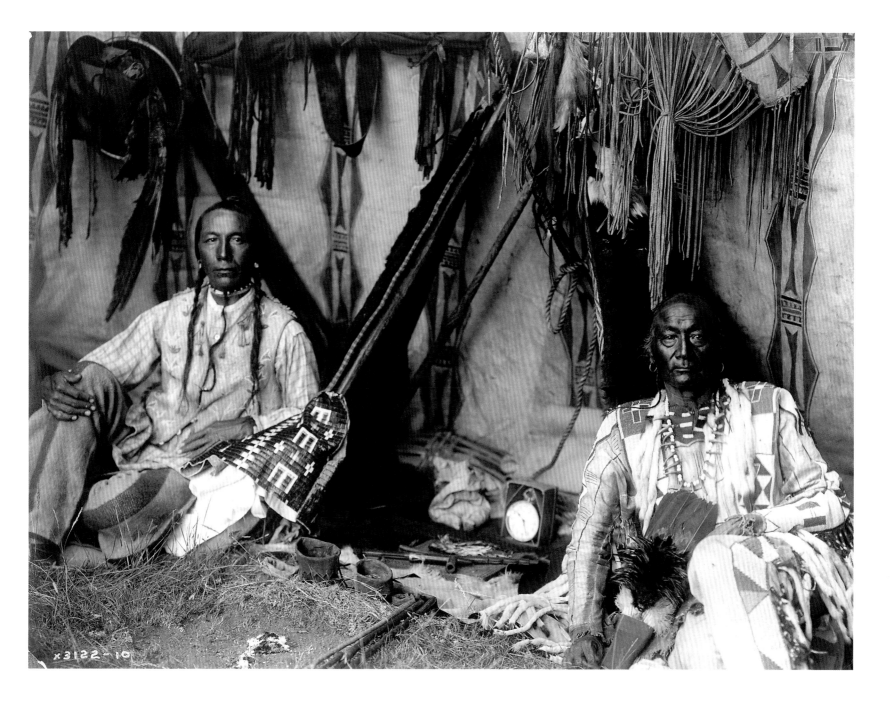

Crow Chief's Daughter,
before 1910

The painted lodges of the Piegan people
were usually owned by the chiefs and were
decorated with symbols representing
mountains, prairies, constellations, stars,
sun, moon, or stylized animals or spirits.
The young girl is Helen Crow Chief
who was born in 1905. Her father,
Crow Chief, was the leader of the Piegan
of Montana and was also photographed
by Curtis. Standing in the entrance of
her painted play tepee, Helen is dressed
in a fringed dress and wearing long
strands of beads. As a young girl she
was already learning the domestic skills
of womanhood.

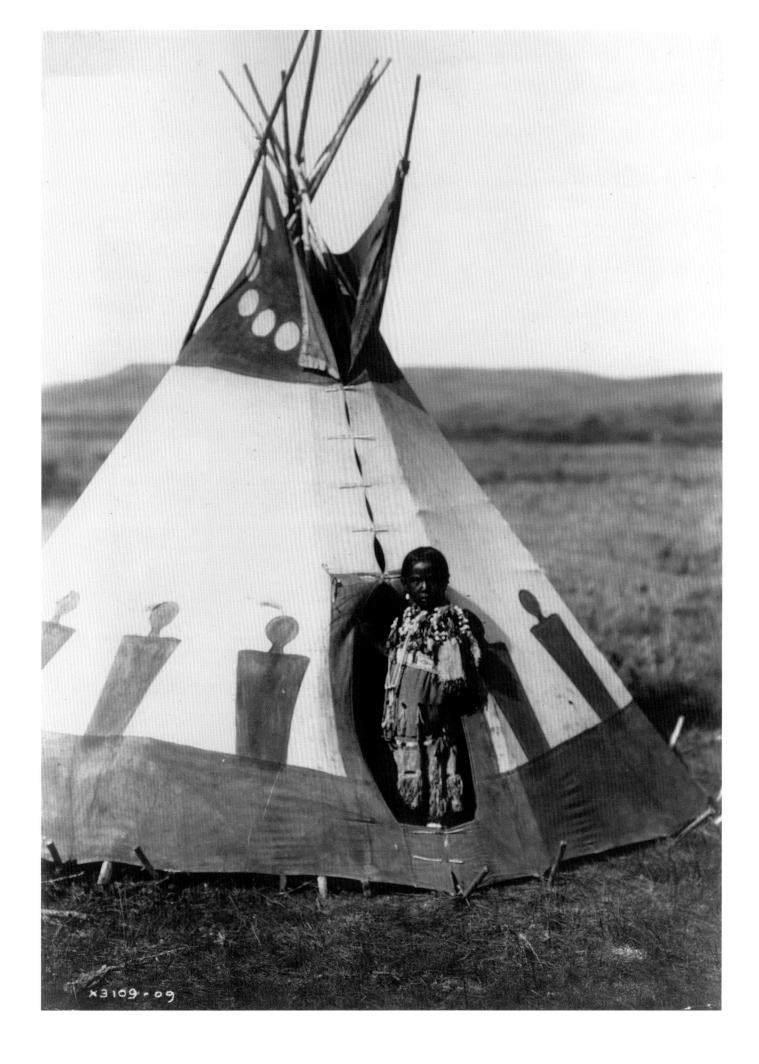

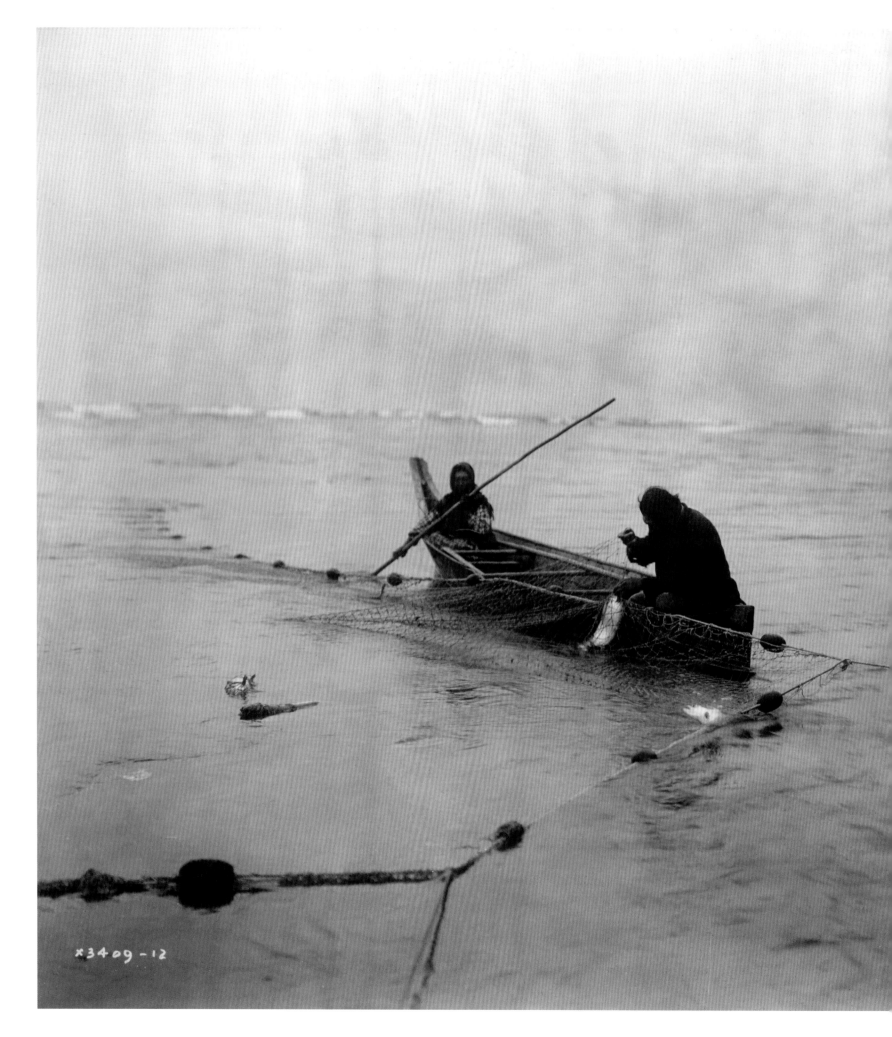

X3409-12

Lifting the Net –
Quinault, 1909–10

For the Quinault, a Northwest Coast
people living on the southern coast of
Washington State, fish was a staple food.
Salmon was of great importance, and each
year its appearance was marked by the
First Salmon ceremony. The first fish
caught was laid on the bank with its head
pointing upstream. The salmon was then
cut open with a musselshell knife and its
entrails removed. The head was left
attached to the backbone, and the heart
was burned in a fire. Everyone received
a portion of this first fish. In this
photograph Curtis captured a salmon
being removed from a gill net, 'usually
woven from the long, slender withes of
swamp willow. Another willow net was
set by suspending it horizontally between
anchored canoes and a little below the
surface of shallow waters in narrow inlets.
When a school of salmon passed over it
the net was quickly lifted' (volume 9).

The Tule Gatherer, 1909–10

The Cowichan were a people of the Northwest Coast culture area who lived on the eastern shore of Vancouver Island. Here a Cowichan woman gathers tule (or cattail), a tall and resilient reed that grows wild in the lakes, ponds and surrounding wetlands. The women wove the tule into mats of various sizes: some were used as rain coverings or capes, others as bedding. Large mats served as roofing for their summer shelters or covered the walls and floors of winter houses, while small mats were used as padding for canoe bottoms. A picturesque view framed by water, this photograph is an example of the aesthetically balanced image often created by Curtis.

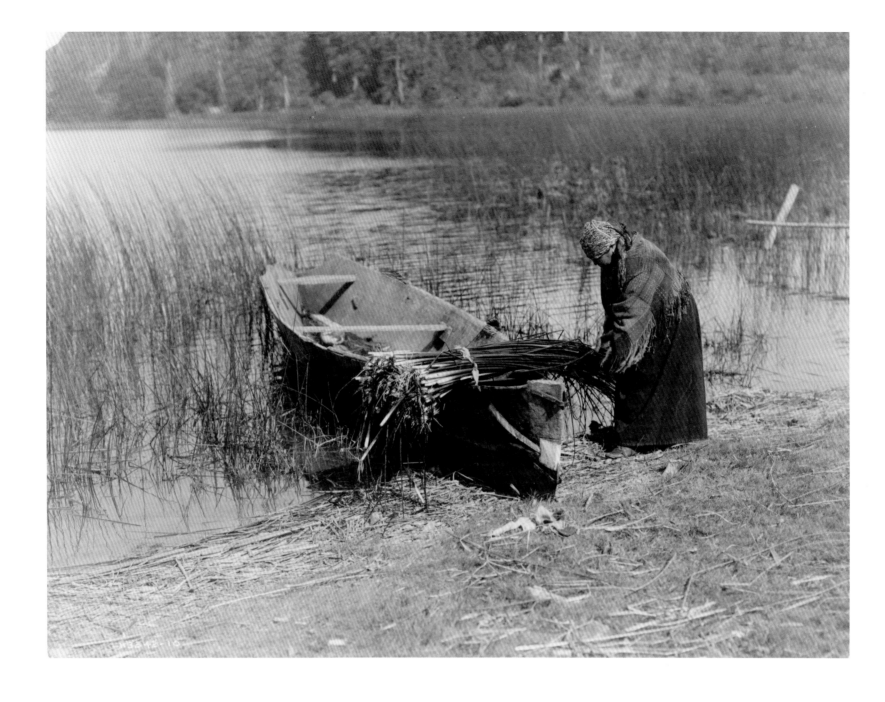

Wife of Mnaínak—
Yakima, 1909–10

Mnaínak was the son of a headman of a village called Skin, lying north of the Columbia River in Washington State, an important fishing centre in the Plateau culture area. Mnaínak, who belonged to the western Columbia River Sahaptins, married a woman from the neighbouring Yakima tribe in the north of Washington State. In this portrait, Mnaínak's wife wears a heavily beaded buckskin dress and a basketwork hat. Once such hats were part of the everyday costume worn by women, but from the late 1800s they were worn only for special or ceremonial occasions. A unique feature of the Plateau basketwork hat was the hide tie that the basketmaker used to gather the warp strands when she started the hat. When it was finished the basketmaker might fasten a decorative item to the end of the tie, which hung from the centre of the hat's crown, as shown here.

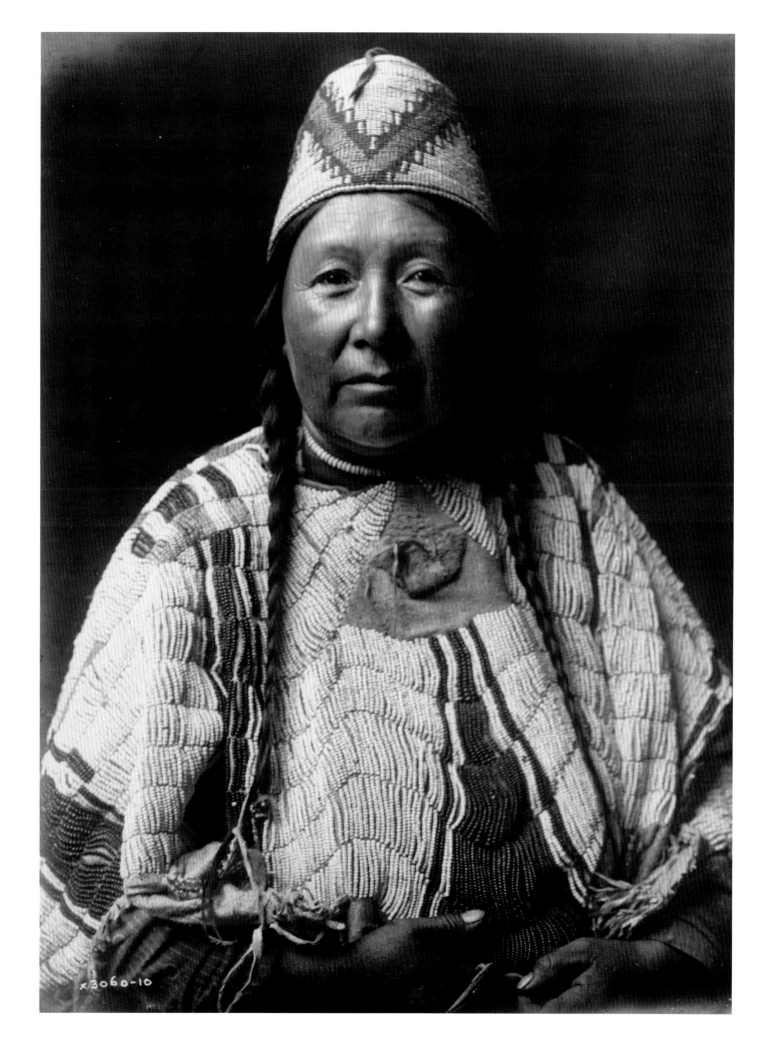

X3060-10

Páqůsilaħl Emerging from the Woods – Qágyuħl, 1910

The Kwakiutl (modern spelling of Qágyuħl) of the Northwest Coast culture area had a rich ceremonial life. Here, a man from the Fort Rupert community in British Columbia is dressed as a spirit figure, also known as the Woodman or Bekw'és, and is depicted emerging from the forest wearing a mask and costume of evergreen boughs. This exact wooden mask was collected from the Kwakiutl in 1915 by an ethnologist from the Milwaukee Public Museum. It is made of wood with eyes represented by orbs, a projecting nose and mouth, and bared teeth that created a menacing visage. This photograph was not of an actual ceremony, but of a reconstruction for Curtis who was intent on photographing all the masks in action.

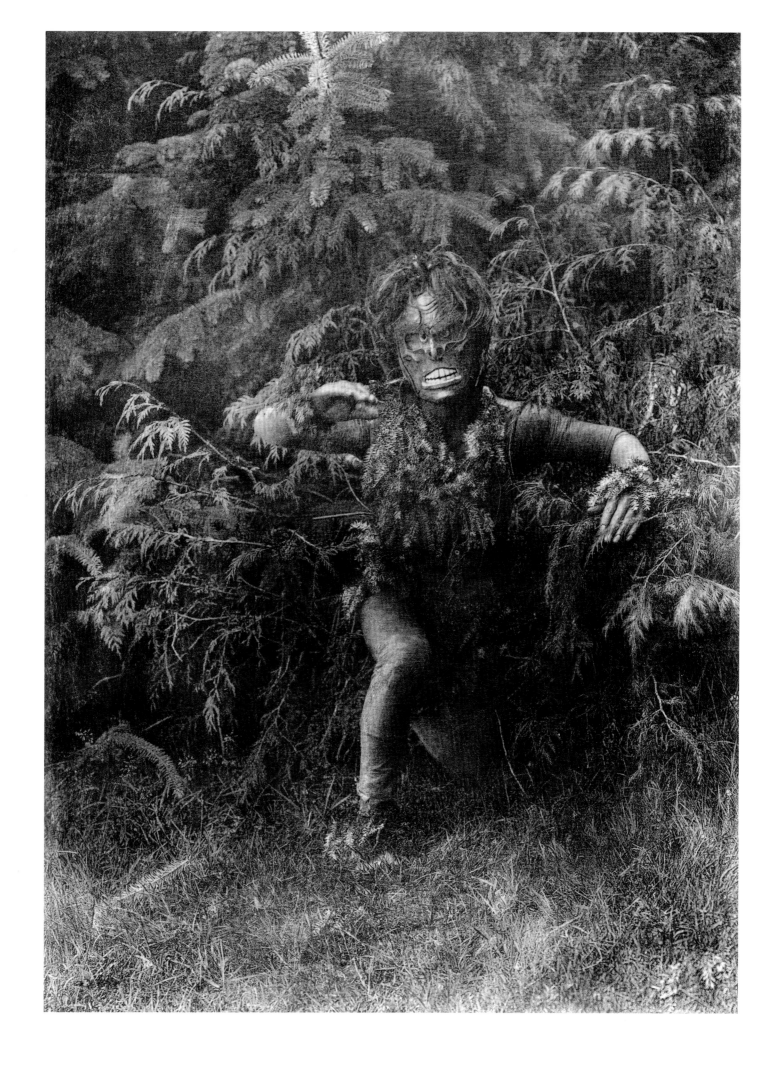

A Nakoaktok Chief's Daughter, 1910

On the northwest coast, potlatches were ceremonial and social public events during which property was distributed to invited guests who bore witness to the wealth and status of the host. According to Curtis, 'when the head chief of the Nakoaktok [a Kwakiutl group] holds a potlatch his eldest daughter is thus enthroned, symbolically supported on the heads of her slaves' (volume 10). She is wearing a twined robe of yellow cedar bark, a basketwork hat decorated with pieces of abalone shell, large abalone earrings, bracelets of engraved silver and a nose ring. These items were indications of her wealth and high status. Curtis was always concerned with aesthetics in his photographs. In setting up this image he may have been intrigued by the similarity of the woman's facial features to those of the wooden statues.

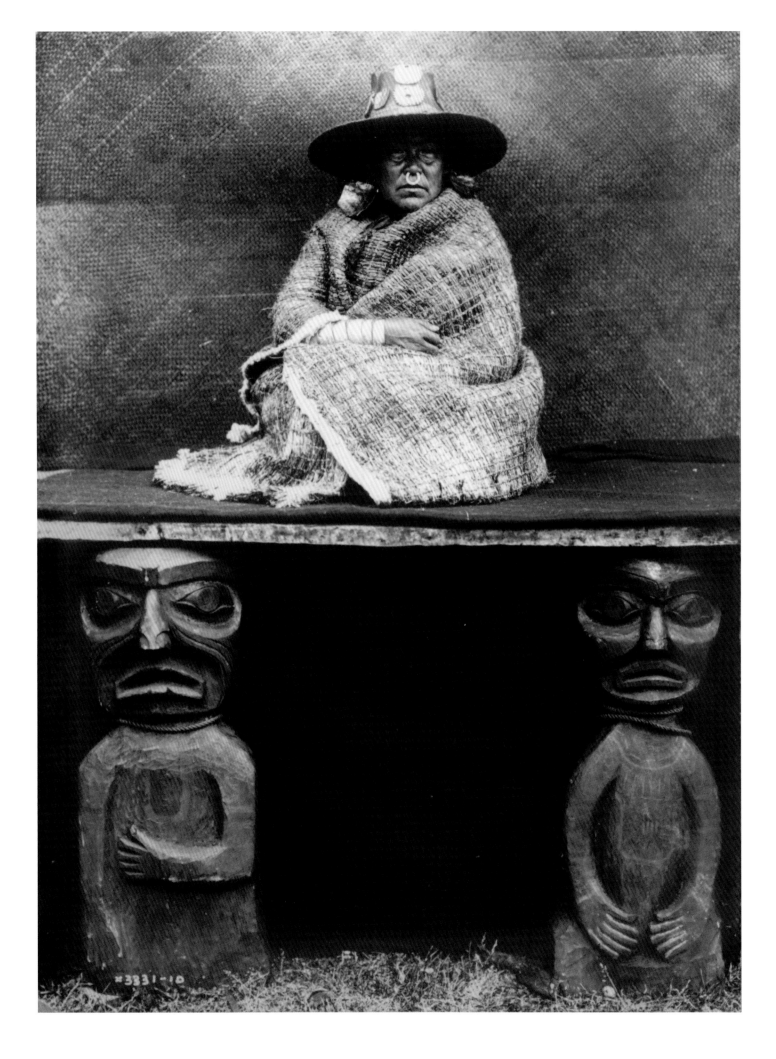

Diegueño House at Campo,
1916–22

The Tipai-Ipai (known in Curtis's time as Diegueño) were from the Campo Reservation, and lived in a town just north of the Mexican border in the southern part of the California culture area. This summer house was made of poles and brush thatch. The Tipai-Ipai hunted and gathered acorns as their staple food, in addition to a variety of wild plants, and also practised limited farming. One of their dietary supplements was agave, or baked mescal, which was gathered primarily by the women in springtime. Traditionally, Tipai-Ipai women wore a one- or two-piece apron and a basketwork cap, but by the time Curtis photographed them they were wearing Euro-American clothing. The scarf was a substitute for the basketwork cap.

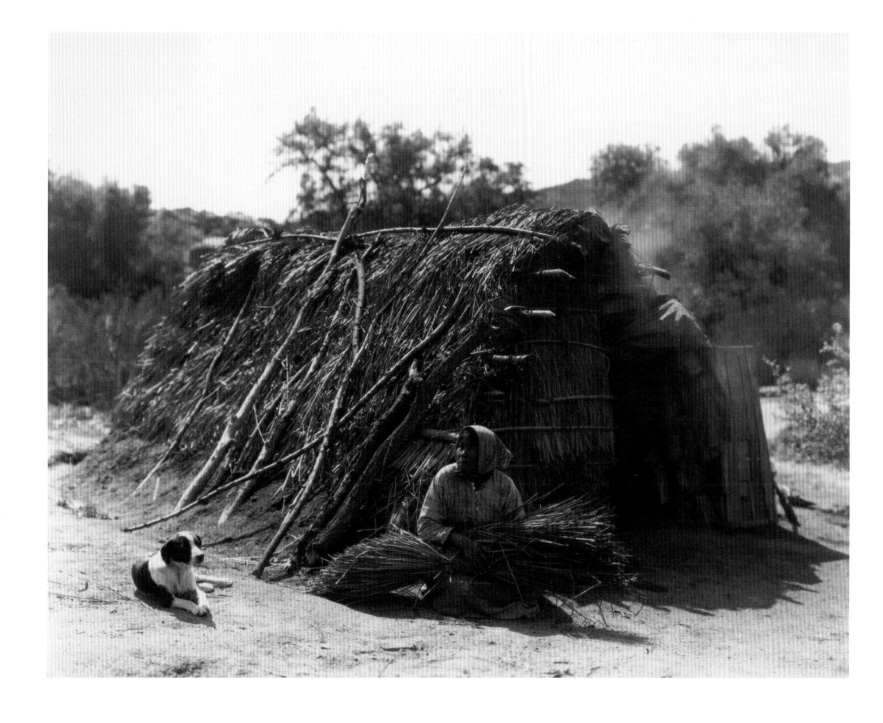

Wife of Modoc Henry —
Klamath, 1916–17

This elder is wearing a cloth cap
decorated with beads and olivella shells.
Curtis took the image on the Klamath
Reservation, Oregon, where the Modoc
were located together with the Klamath
and other peoples of the Plateau culture
area. Like many of Curtis's evocative
photographs, this one was the inspiration
for a painting — in this instance, one
made in 1992 by Frederick Brown
entitled *She Knows How*. The painting's
title was meant to convey wisdom
and timelessness, reflecting her aged
appearance, and exemplifies the
liberties taken with Native American
portraits when they are presented
in a generic, naturalistic framework.

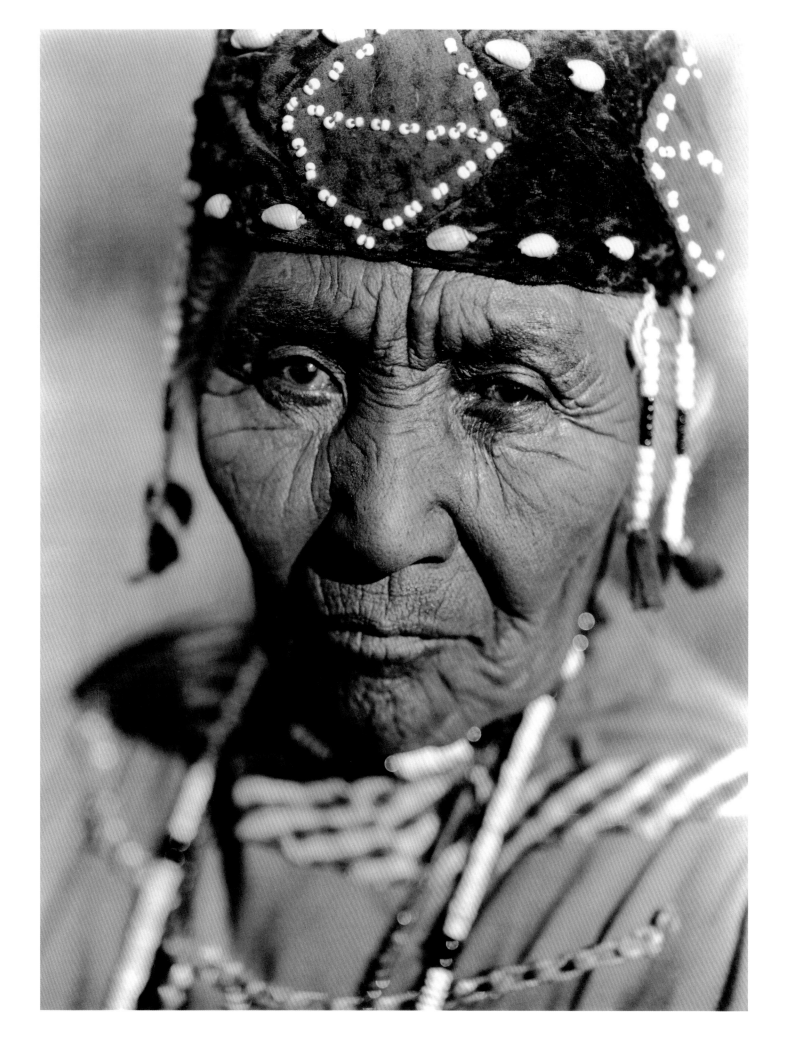

Klamath Warrior's
Headdress, 1916–17

Bennett Weeks, a resident of the
Klamath Reservation in Oregon, was
photographed by Curtis wearing a woven
tule hat made by a twining process and
decorated with feathers. Such hats were
customarily made by the women, who
also wove baskets, made cordage, tanned
hides and in general made all clothing.
This portrait presents the subject in
ethnographically identifiable clothing
and looking directly at the photographer,
and is typical of Curtis's many powerful
portraits of Native Americans.

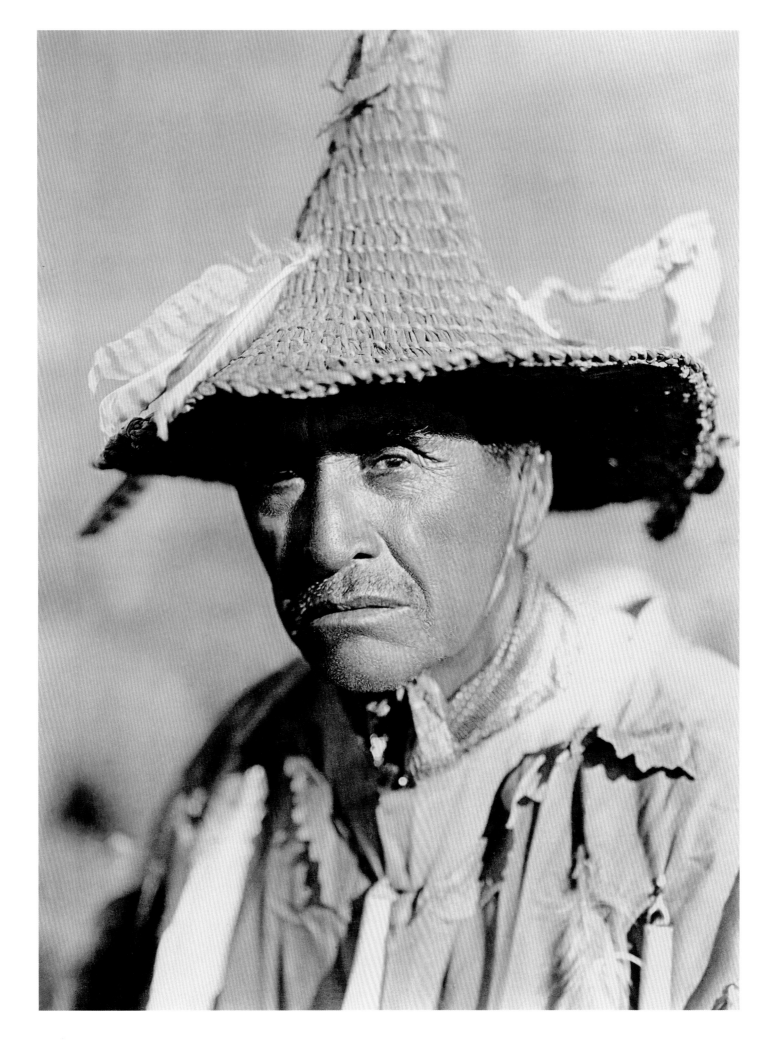

Tolowa Dancing Headdress,
1916–17

This man, Sam Lopez, is shown wearing
a redheaded woodpecker scalp headdress
and strings of dentalium shell beads.
He was a member of the Tolowa tribe in
the California culture area, located in
northwestern California along the Pacific
Ocean coastline. Curtis noted that,
'The headdress is of the type common to
the Klamath River tribes – a broad band
of deerskin partially covered with a row
of red scalps of woodpecker' (volume 13).

He is holding an obsidian blade and a
traditional painted bow. The acquisition
of such treasures as woodpecker scalp
headdresses, shell necklaces and obsidian
blades was important in Tolowa society
as a means of gaining prestige.

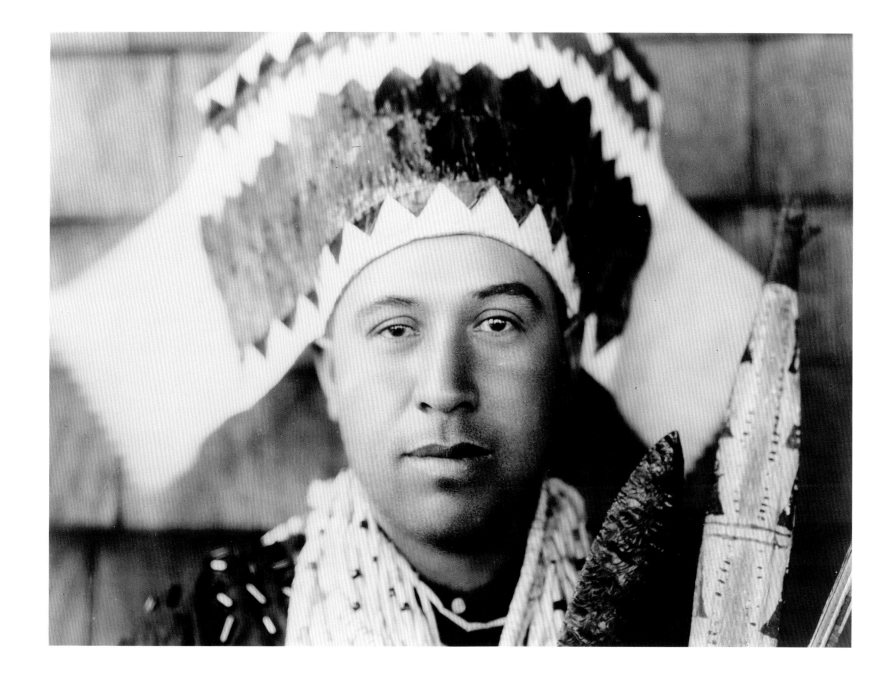

This is a portrait of Cecilia Joaquin,
a Pomo living on the Hopland Rancheria
in Mendocino County, within the
California culture area. 'Rancheria'
were small settlements established in the
late-nineteenth century on white-owned
lands. Some Californian tribes were able
to gain control of the rancherias, which
were commonly-owned property, but
the Hopland Rancheria was terminated
in 1958. Here Cecilia is shown collecting
seeds. A beater was used to knock the
seeds from wild plants into a basket.
Curtis also photographed her carrying
the basket by a tumpline (leather strap)
across her forehead. Gathering food
was a year-round undertaking: women
collected seven kinds of acorns, which
served as the staple food, supplemented
by buckeye nuts, berries, seeds, roots,
bulbs and edible greens. Vegetables were
eaten fresh, or dried and stored.

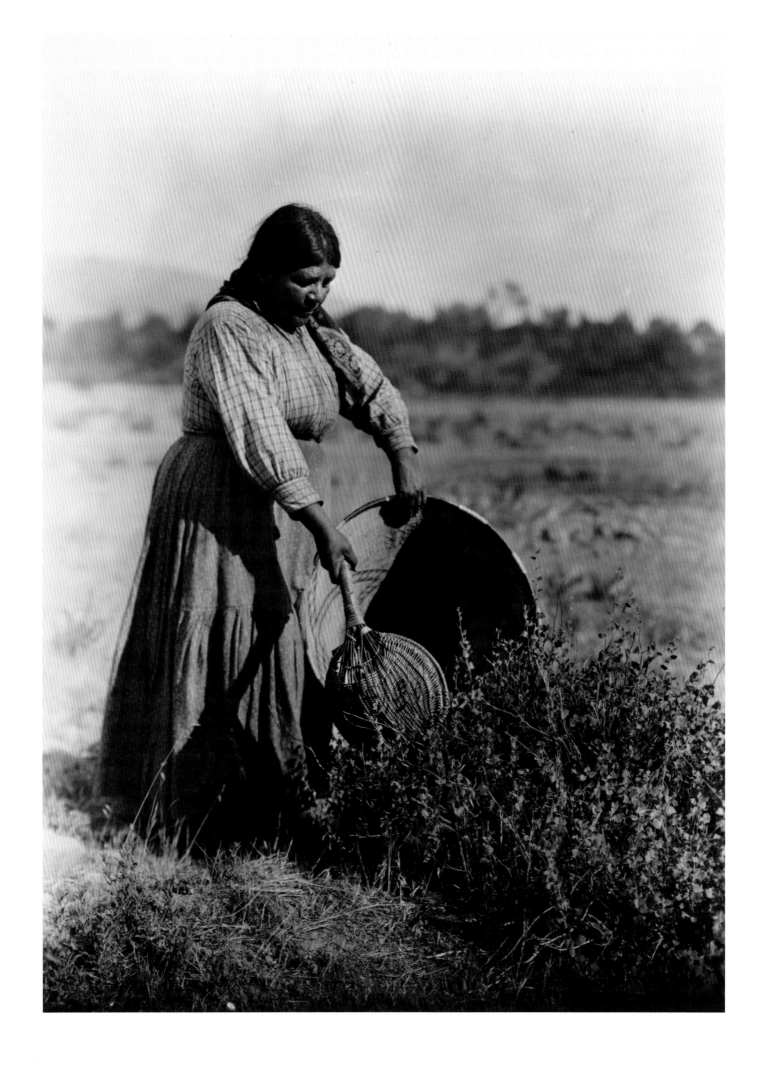

This Northern Paiute (the modern term
for the tribe that Curtis called Paviotso)
woman of the Great Basin culture area
in Nevada was photographed by Curtis
sitting in front of her summer house
of willow poles and thatch, which appears
to be open on the top. A rabbit skin
blanket hangs on the side of the door and
may have been pulled across it to close
off the entrance at night. A number
of twined willow winnowing and parching
trays stand in front of the house. They
were used in the preparation of pine nuts
(the most important food source for the
tribe), in sifting to separate seeds from
chaff, and in separating seeds of different
sizes. Baskets were also used for roasting
pine nuts.

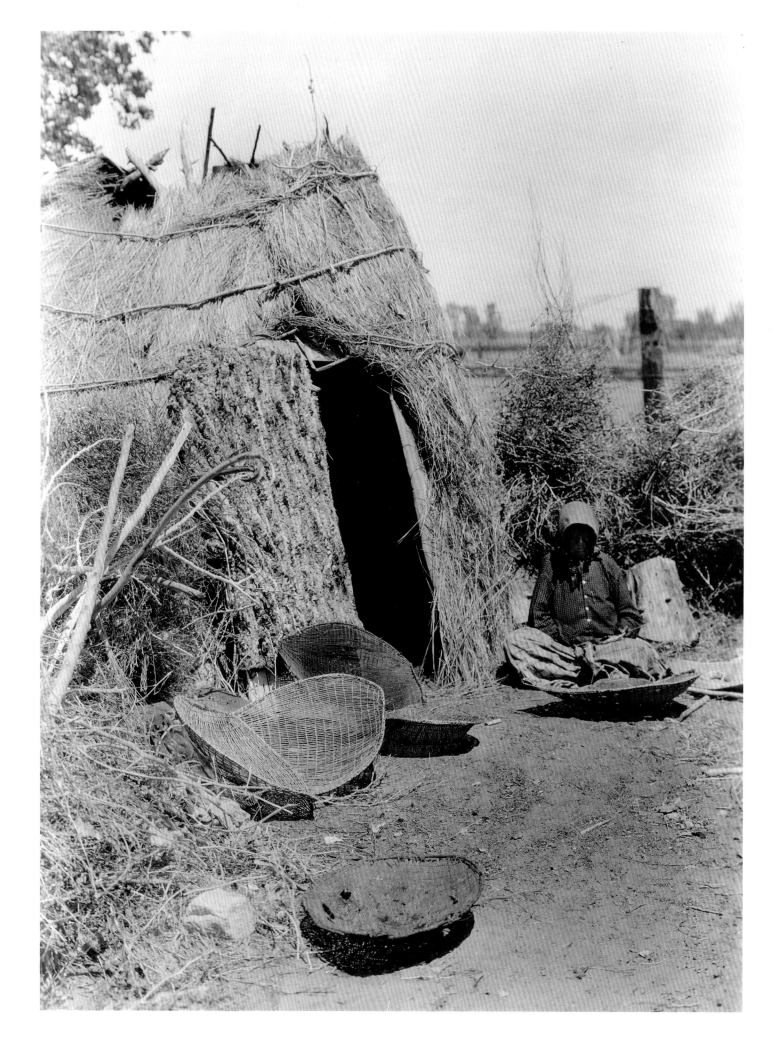

Fishing from a Platform, 1923

The Hupa were a group from the California culture area. Here a man stands on a small platform over the Trinity River from which he could catch salmon, steelhead, sturgeon or lamprey eels using a long-handled dip-net. All of these fish would be sliced, smoke-dried and preserved in large quantities for winter consumption. Florence Curtis Graybill, Curtis's daughter, travelled with her father during his fieldwork among the Californian Native Americans. She commented of her experience: 'We were working our way [by canoe] northward along the coast of California … there was moisture from sky and sea. I wondered how Father would be able to make pictures, but he did, which never ceased to amaze me.'

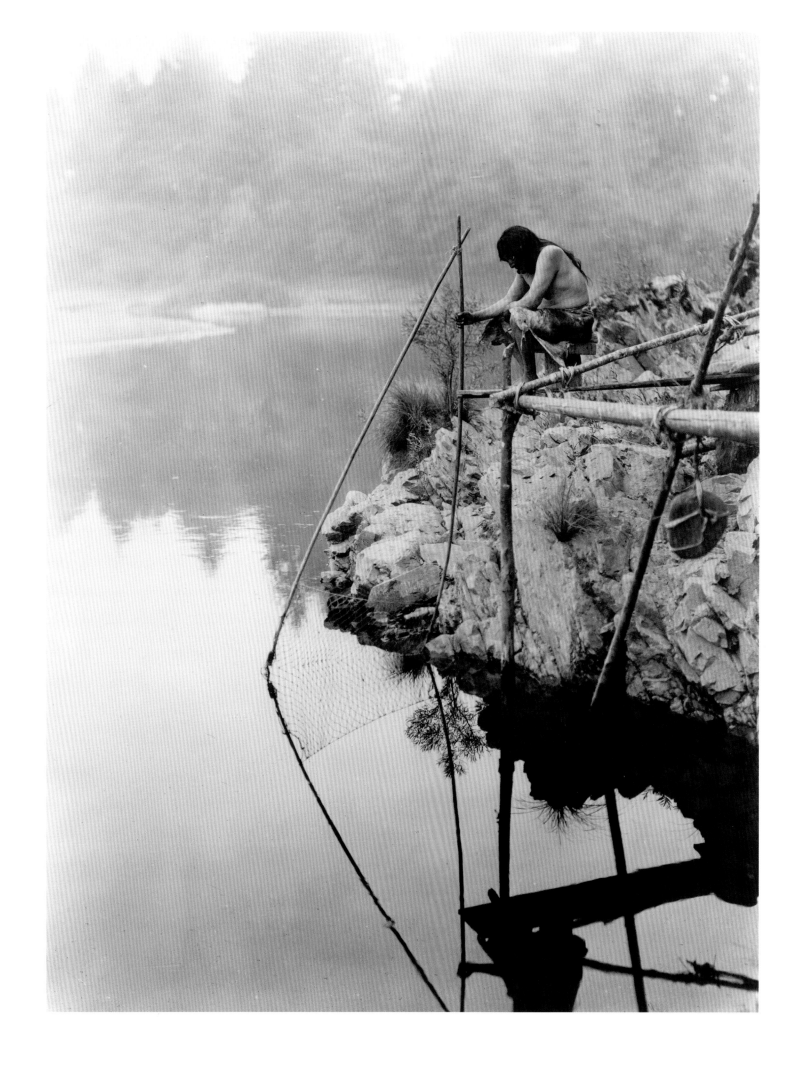

Klamath Woman, 1923

This woman is Lizzy Hook, a member of the Klamath tribe in the Plateau culture area located in southern Oregon. She displays her wealth by wearing a fur cap decorated with shells, beads and bells. Her dress is decorated with a beaded strip along the shoulder seam. Both sexes wore their hair either loose or braided, one braid for women and two for men. The hair was combed with an implement made from a porcupine tail or from grass, and in earlier times was dressed with grease. Like many women of her tribe she was an accomplished basketmaker. Such baskets were used as household containers, trays, baskets for carrying heavy loads, seed beaters and cradles.

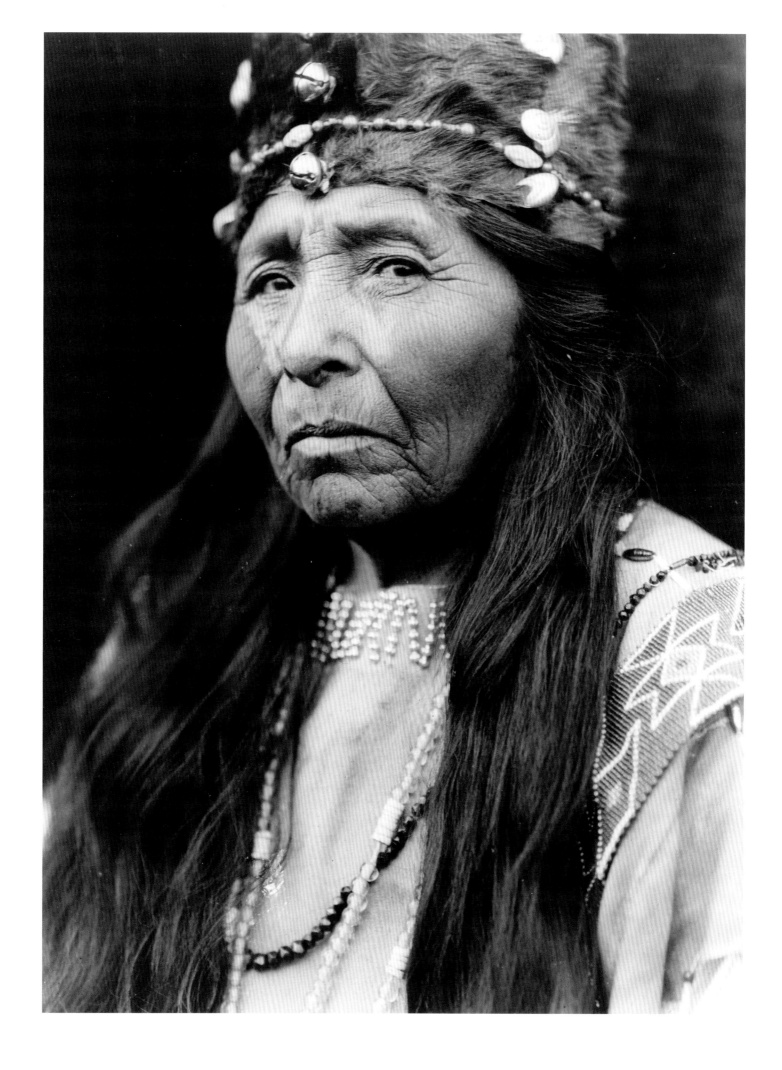

A Blackfoot Travois, 1925

This photograph was taken among the Blackfoot of Canada. Curtis noted that 'the travois is still used for transporting bundles of ceremonial objects. Before, and sometimes even long after, the acquisition of horses, travoix were drawn by dogs' (volume 18). The availability of horses from the mid-nineteenth century onwards allowed the Blackfoot to transport larger tepees, which were made from twelve to fourteen bison skins and needed twenty to thirty poles to support them. The couple are wrapped in Hudson Bay Company blankets. Such heavy wool blankets were a staple trade item in the nineteenth century and sought after by Native Americans who exchanged furs for the prized blankets.

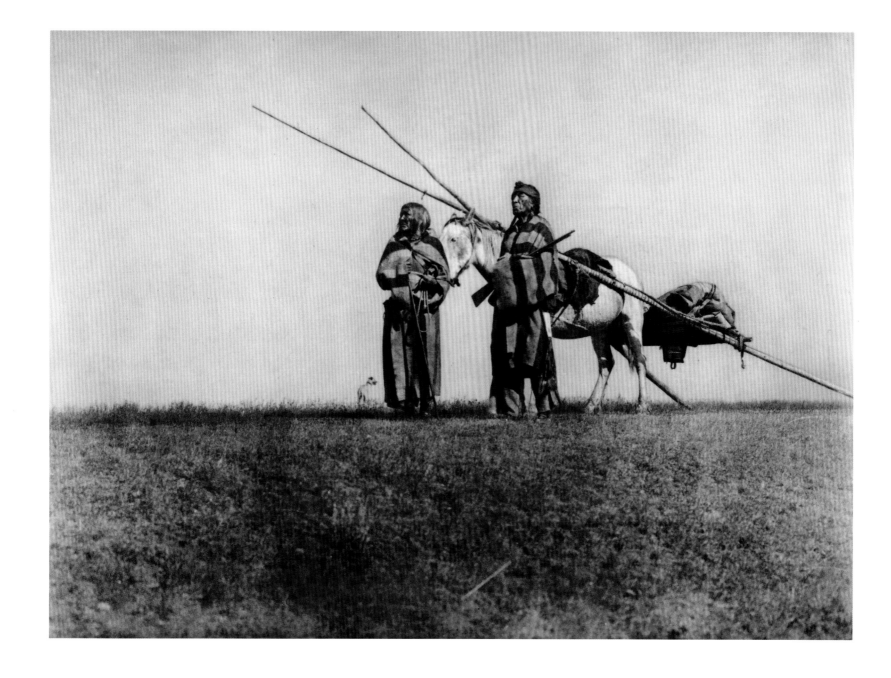

Calling a Moose – Cree, 1925

A Western Woods Cree man of the Subarctic culture area here demonstrates the use of a birchbark horn for attracting a moose by imitating their communication sounds and calls. A moose normally doubles back after feeding in order to rest at a spot downwind of its previous trail, where it will catch the scent of any following predator. A hunter therefore does not directly follow the trail of a feeding moose, but rather makes semicircular loops downwind from it until the moose's trail doubles back and he encounters his prey. This dramatic photograph, full of subtle textures and light tones, was used as an illustration for Curtis's text about the Cree in volume 18. A tightly cropped version of the same picture appeared as a folio plate.

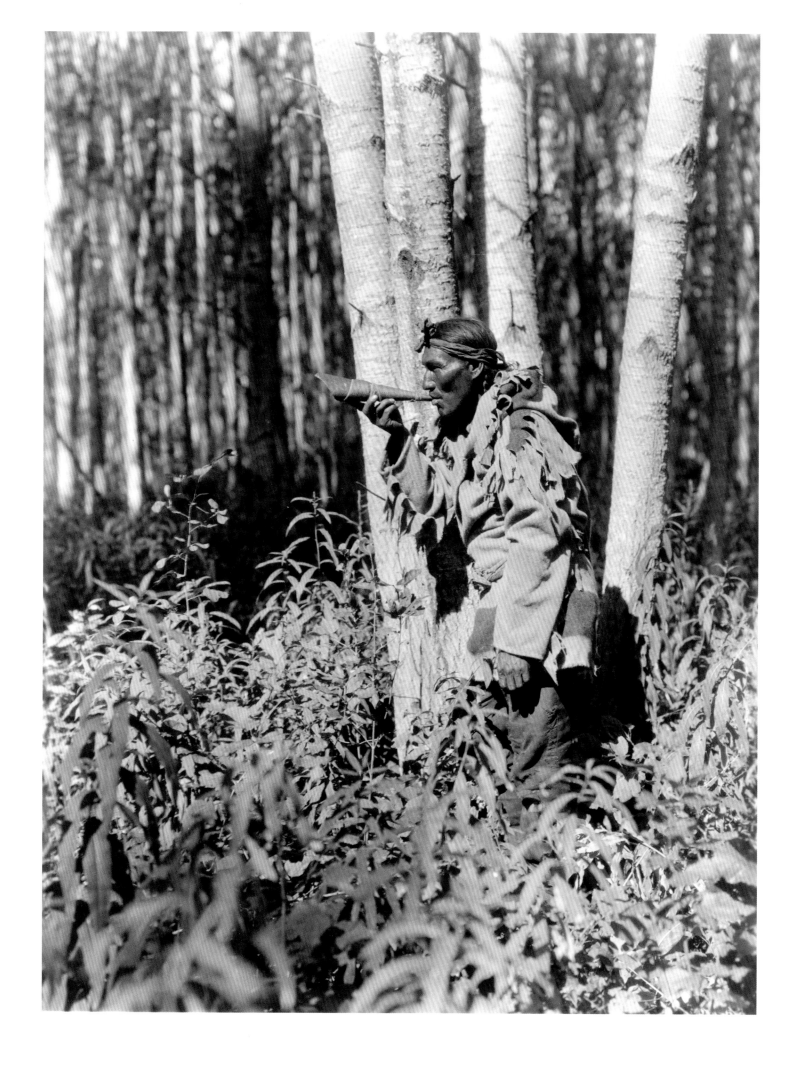

Woman's Costume and Baby
Swing – Assiniboin,
before 1926

A woman from the Stoney tribe (called Assiniboin by Curtis) in the Plains culture area of Canada is shown here wearing a buckskin-fringed dress decorated with beadwork. The child's cradle is a swing made of hide and rope, a common type among a number of tribes. Curtis wrote, 'The northern Assiniboin used the regulation Plains costume of deerskin clothing – shirt and hip length leggings for men, dress and knee length leggings for women, moccasins and robes for both sexes' (volume 18). This photograph is a romantic picture of a mother and child, a theme the photographer used and framed artfully here, as well as in another view of the same subjects.

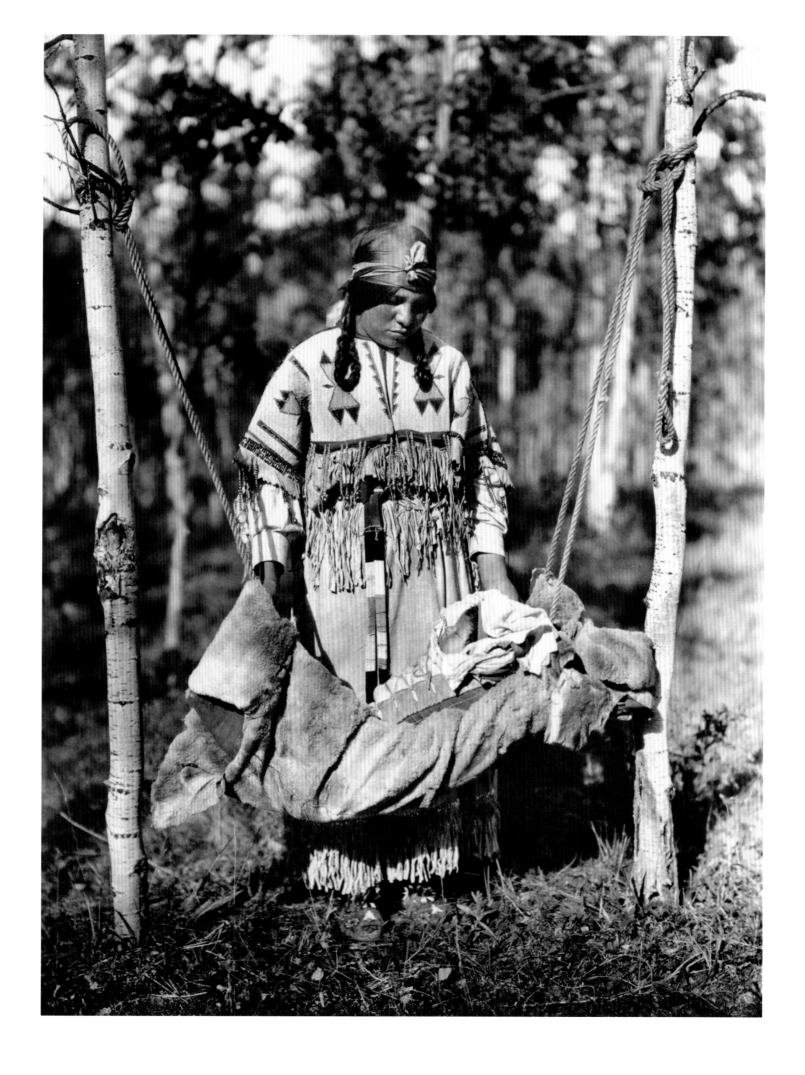

Buffalo Dancers, Animal Dance
– Cheyenne, 1926

These Southern Cheyenne women from the Plains culture area in Oklahoma, are wearing the buffalo dance headdresses used in the Massaum or Animal Dance Ceremony. During this ritual, which acted out the story of how the Cheyenne obtained the animals they needed for survival, medicine men and women dressed as animals and were endowed with healing powers. The fringed shawl, worn as a skirt, was part of their formal dress.

'All about the camp the sick and afflicted, the lame and the blind, were brought out and placed on the ground in front of their tents,' wrote Curtis. 'As the Buffalo reached one of the ailing, they circled around him and the cow leader performed her healing incantations over the body. As the band started to file away, the bull closed the shamanistic performance by crouching down and sucking the evil from the body of the patient' (volume 19).

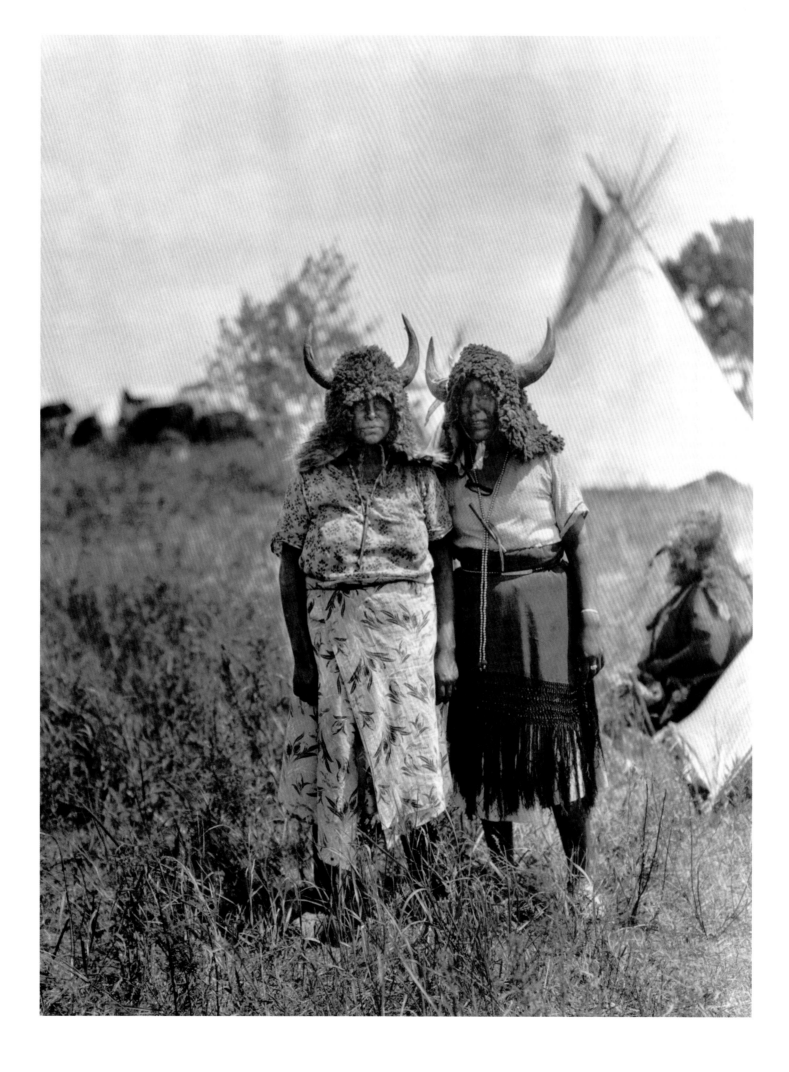

Maskette, Nunivak, 1927

This is a portrait of a Nunivak Eskimo man of the Arctic culture area who was living on Nunivak Island in the Bering Sea, off the coast of Alaska. He was known as Davis and is pictured wearing a forehead mask representing a predatory bird carrying a fish in its mouth. Carved wings were mounted on three-inch feathers inserted into the hoop and a miniature spear, feather-mounted, was stuck in the top of the bird's head.

The common forms of maskettes were the heads of animals, birds or fish mounted on hoops or headbands. According to Curtis, they were representative of the spirit-powers of their owners and were believed to imbue them with the spirit of the animal, bird, fish or object that the maskette depicted (volume 20).

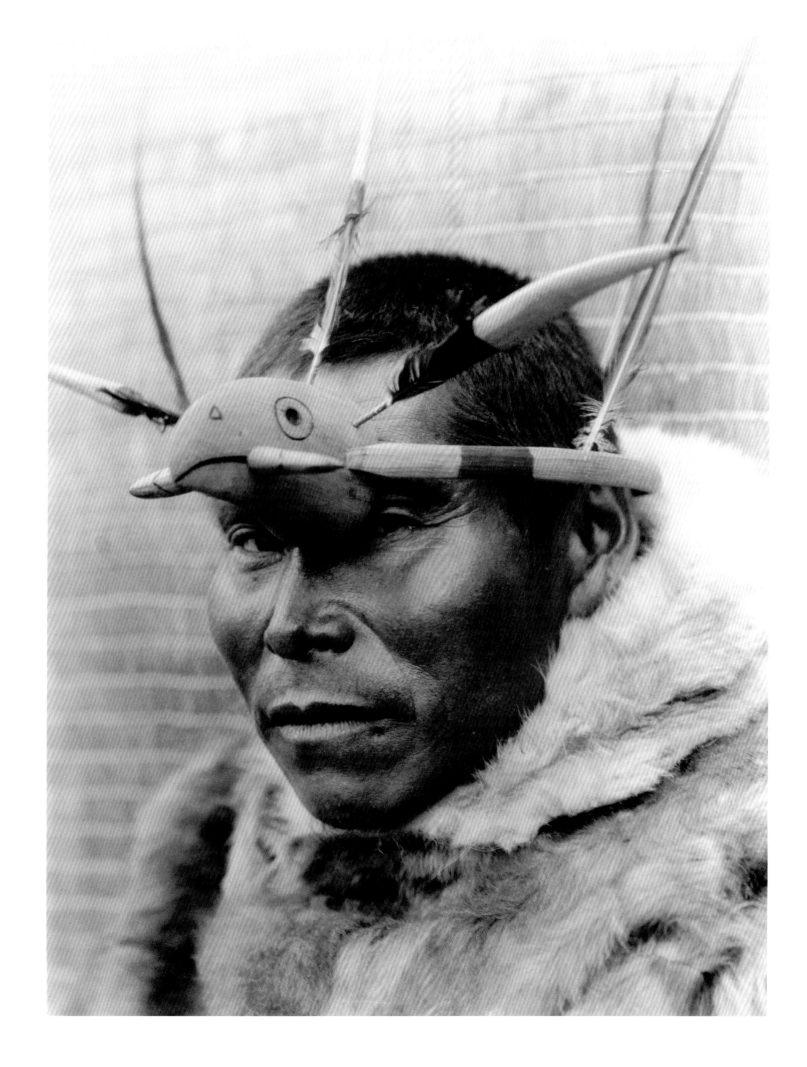

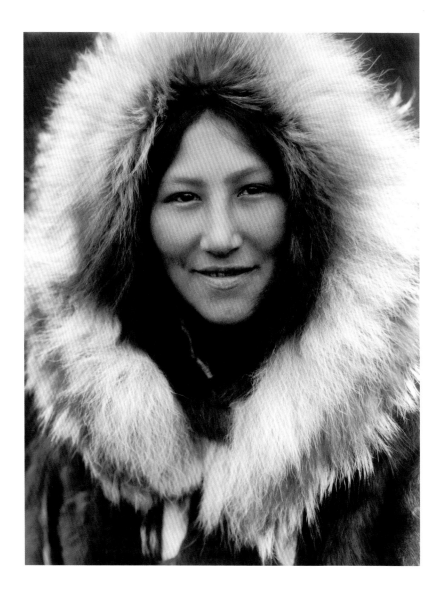

The photographs *Óla Noatak* (above) and *Noatak Child* (right) are portraits of the wife and one of the children of Paul Ivanoff, Curtis's interpreter during his 1927 field trip. They lived on Nunivak Island where Paul was the local representative of the Lomen Reindeer Corporation, one of the enterprises that had been introduced. Paul, half-Russian and half-Eskimo, spoke not only the Nunivak language but several of the mainland languages as well.

Curtis's daughter Beth Curtis Magnuson wrote about meeting Óla Noatak, noting that, 'Mrs Paul is charming, quite bashful and shy'. Both mother and child wear traditional fur parkas in the two images. The child's fingers are positioned in a manner that may indicate his dexterity in playing string games, a favourite pastime of many Alaskan natives.

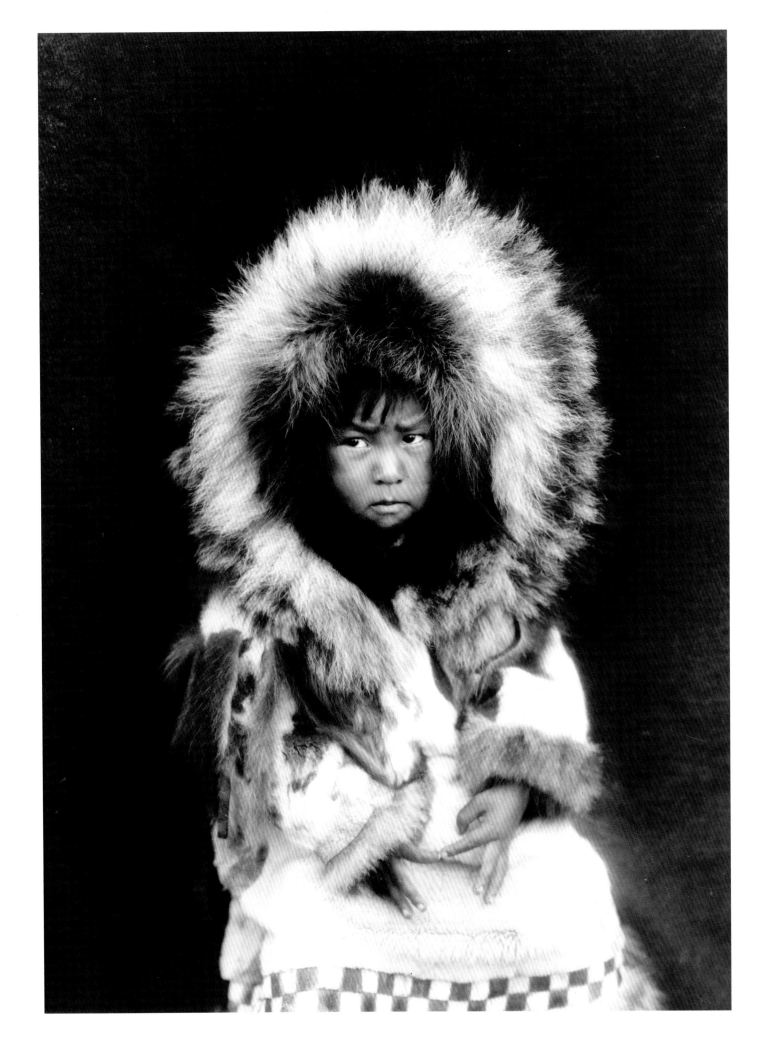

Woman and Child –
Nunivak, 1927

This picture shows a Nunivak woman,
Aanarang, and her son, Joe Moses.
In the traditional division of labour,
Nunivak Island women were in charge of
early child-rearing as well as making and
repairing clothing, and gathering
and preparing food. The parka she wears
here was made of bird skins, probably
cormorant, eider or murre (a diving bird),
which made especially warm garments.
The mother-and-child theme,
emphasized by Curtis's use of a backdrop
to remove any 'mundane' background,
creates a romantic, Pictorialist effect.

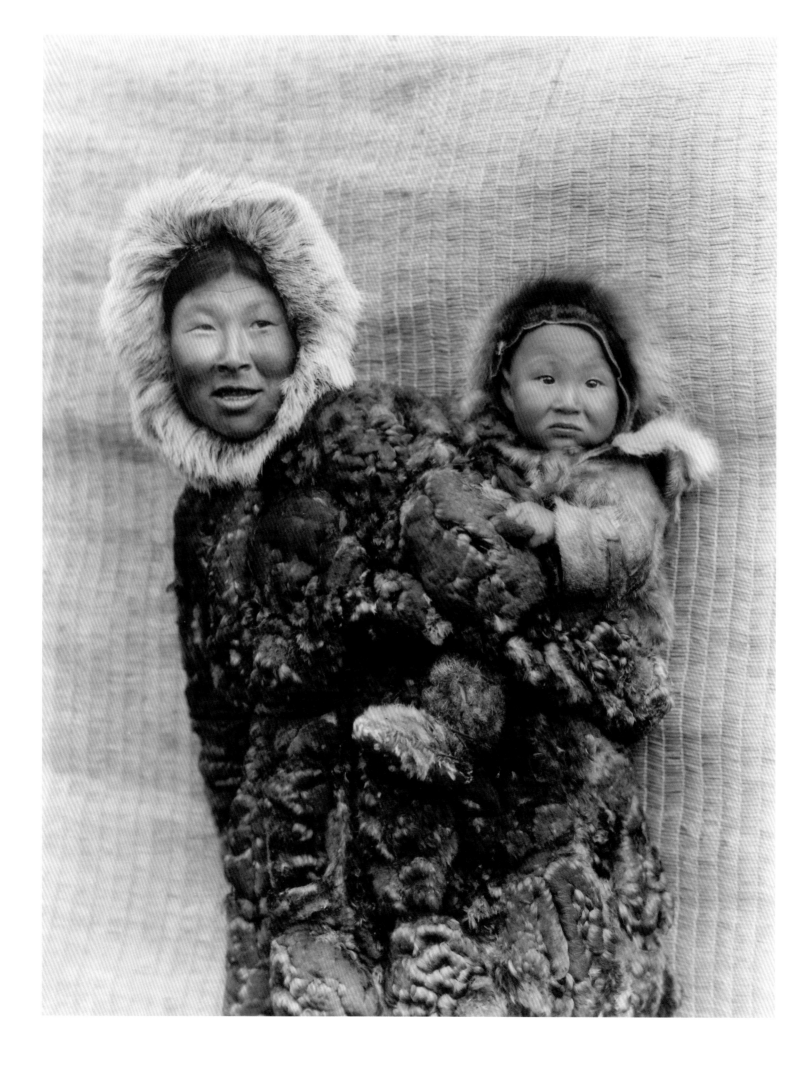

Cutting Up A Beluga –
Kotzebue, 1927

The beluga whale was hunted by Kotzebue men who lived on the coast of northwest Alaska. This hunting was done in summer in kayaks. Curtis reported, 'when the hunters return, first the heads are cut off and left in the water in order that the spirits of the animals may return to the sea and enter the bodies of other belugas' (volume 20). The women would process the meat (or *muktuk*), cutting it with a special, very sharp, half-moon shaped knife called an *ulu*. The beluga would be cut into linked rectangular sections, hung to dry, boiled in salt water, drained and stored for future use, or traded. Curtis was thrilled to find traditional life still practised during his fieldwork in the Arctic and to get 'real pictures illustrative of their mode of living, not merely the portraits we had to fall back on last summer' when he was in Oklahoma.

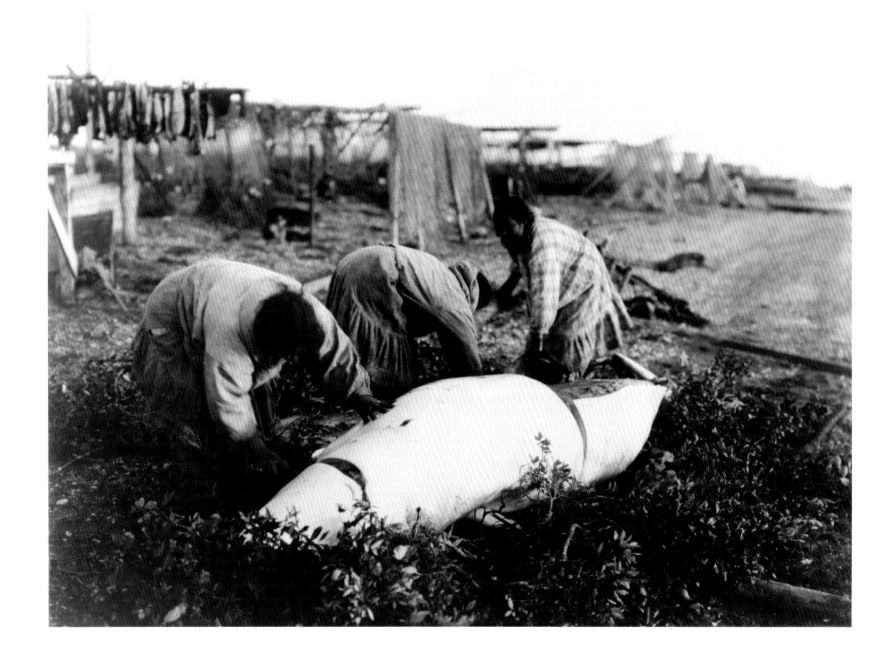

Waterproof Parkas —
Nunivak, 1927

This portrait shows Lena Wesley, also
known as Naqugutalngur (left) and
Agyaq'er (right) from Nash Harbor,
Nunivak Island. They wear waterproof
gut-skin parkas that were typically
worn by men in boats when hunting sea
mammals, or by both sexes during bad
weather. Henry Collins, a Smithsonian
archaeologist working on Nunivak
Island during Curtis's visit of July 1927,
observed that Curtis instructed the
Nunivak where and how to pose, and
sometimes asked them to dress up in
clothing that Collins said Curtis had
brought with him. The women stand on
a grassy sand dune, gazing out to sea.
Curtis had been struck by this picturesque
scene, according to his log of the trip
when he first arrived. That he used this
scenic view as a backdrop for his image
is thus not surprising.

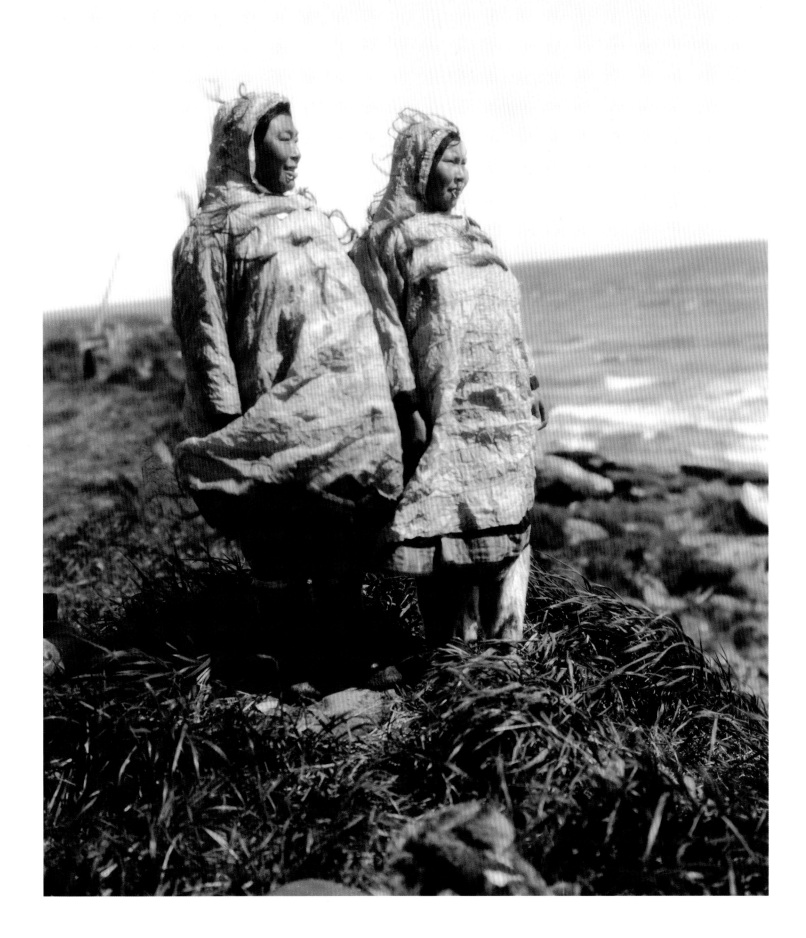

4 University of Washington
 Libraries, Special Collections:
 UW 19573

17 Library of Congress:
 LC-USZC4-8817

19 Library of Congress:
 LC-USZ62-83573

20–21 Peabody Essex Museum,
 Salem: PH76.106

22–23 Smithsonian Institution
 National Anthropological
 Archives: 88-17169

25 Library of Congress:
 LC-USZC4-8860

27 Smithsonian Institution,
 National Anthropological
 Archives: 75-7014

29 Peabody Essex Museum,
 Salem: PH76.105

30 Library of Congress:
 LC-USZ62-49148

31 Smithsonian Institution,
 National Anthropological
 Archives: 76-15853

32 University of Washington
 Libraries, Special Collections:
 UW4426A

33 University of Washington
 Libraries, Special Collections:
 UW2726

35 Library of Congress:
 LC-USZ62-106266

37 Library of Congress:
 LC-USZ62-102041

39 Library of Congress:
 LC-USZ62-90798

40–41 Smithsonian Institution,
 National Anthropological
 Archives: 74-7191

42 *Left*: Peabody Essex Museum,
 Salem: PJ76.4
 Right: Library of Congress:
 LC-USZ62-101843

43 Library of Congress:
 LC-USZ62-48377

45 Library of Congress:
 LC-USZ62-37340

47 Library of Congress:
 LC-USZ62-123606

49 Library of Congress:
 LC-USZ62-107914

51 Peabody Essex Museum,
 Salem: PH76.89

53 Library of Congress:
 LC-USZ62-130415

54–55 Library of Congress:
 LC-USZ62-106478

57 Smithsonian Institution,
 National Anthropological
 Archives: 75-11107

59 Library of Congress:
 LC-USZ62-46952

61 Library of Congress:
 LC-DIG-ppmsca-05085

63 Library of Congress:
 LC-USZ62-106797

65 Library of Congress:
 LC-USZ62-111283

67 Smithsonian Institution,
 National Anthropological
 Archives: 94-7570

69 Smithsonian Institution,
 National Anthropological
 Archives: 89-14346

72–73 Smithsonian Institution,
 National Anthropological
 Archives: 76-4331

75 Library of Congress:
 LC-USZ62-105387

77 Smithsonian Institution,
 National Anthropological
 Archives: 96-10689

78 Smithsonian Institution
 Library: 90-14319

79 Smithsonian Institution,
 National Anthropological
 Archives: 75-11978

81 Library of Congress:
 LC-USZ62-106768

82–83 Smithsonian Institution,
 National Anthropological
 Archives: 86-4150

85 Library of Congress:
 LC-USZ62-115020

87 Library of Congress:
 LC-USZ62-115806

89 Smithsonian Institution
 Library: 86-2847

91 Library of Congress:
 LC-USZ62-59010

93 Library of Congress:
 LC-USZ62-98666

95 Smithsonian Institution,
 National Anthropological
 Archives: 91-13025

97 Smithsonian Institution,
 National Anthropological
 Archives: 79-4309

99 Smithsonian Institution,
 National Anthropological
 Archives: 74-5738

101 Library of Congress:
 LC-USZ62-116525

103 Smithsonian Institution,
 National Anthropological
 Archives: 84-11126

105 Library of Congress:
 LC-USZ62-101257

107 Library of Congress:
 LC-USZ62-110506

109 Library of Congress:
 LC-USZ62-61937

111 Smithsonian Institution,
 National Anthropological
 Archives: 56-963

113 Smithsonian Institution,
 National Anthropological
 Archives: 76-13370

115 Smithsonian Institution,
 National Anthropological
 Archives: 76-15880

117 Smithsonian Institution:
 Dibner Library: 83-3665

118 Library of Congress:
 LC-USZ62-89841

119 Library of Congress:
 LC-USZ62-107281

121 Library of Congress:
 LC-USZ62-107285

123 Library of Congress:
 LC-USZ62-115975

125 Library of Congress:
 LC-USZ62-88326

Further reading

George P. Horse Capture, 'Foreword', in Christopher Cardozo (ed.), *Native Nations: First North Americans as Seen by Edward Curtis*, Little, Brown and Company, Boston, 1993

Edward Curtis, *The North American Indian: Being a Series of Volumes Picturing and Describing the Indians of the United States and Alaska*, 20 vols, Plimpton Press, Norwood, MA, 1907–30

—, *The Master Prints*, Arena Editions, Santa Fe, NM, 2001

Barbara A. Davis, *Edward S. Curtis: The Life and Times of a Shadow Catcher*, Chronicle Books, San Francisco, 1985

Sara Day (ed.), *Heart of the Circle: Photographs by Edward S. Curtis of Native American Women*, Pomegranate Artbooks, San Francisco, 1997

Frederica De Laguna, 'Tlingit', in Wayne Suttles (ed.), *Handbook of North American Indians: Volume 7, Northwest Coast*, Smithsonian Institution Press, Washington, DC, 1990, pp. 203–228

James L. Dempsey, *Blackfoot War Art: Pictographs of the Reservation Period, 1880–2000*, University of Oklahoma Press, Norman, 2007

James C. Faris, *Navajo and Photography: A Critical History of the Representation of an American People*, University of New Mexico Press, Albuquerque, 1996

Catherine S. Fowler and Lawrence E. Dawson, 'Ethnographic Basketry', in Warren L. D'Azevedo (ed.), *Handbook of North American Indians: Volume 11, Great Basin*, Smithsonian Institution Press, Washington, DC, 1986, pp. 705–37

Loretta Fowler and Regina Flannery, 'Gros Ventre', in Raymond DeMallie (ed.), *Handbook of North American Indians: Volume 13, Plains*, Smithsonian Institution Press, Washington, DC, 2001, pp. 677–94

Mick Gidley, *Kopet: A Documentary of Chief Joseph's Last Years*, Contemporary Books, Chicago, 1981

—, 'The Vanishing Race in Sight and Sound: Edward S. Curtis's Musicale of North American Indian Life', in *Prospects: An Annual of American Cultural Studies*, vol. 12, Cambridge University Press, MA, 1987, pp. 59–87

—, *Edward S. Curtis and the North American Indian, Incorporated*, Cambridge University Press, MA, 1998

—, 'Ways of Seeing the Curtis Project on the Plains', in Mick Gidley (ed.), *The Plains Indian Photographs of Edward S. Curtis*, University of Nebraska Press, Lincoln, 2001

—, *Edward S. Curtis and the North American Indian Project in the Field*, University of Nebraska Press, Lincoln, 2003

—, 'Edward S. Curtis' Photographs for "The North American Indian": Texts and Contexts', in Ulla Haselstein, Berndt Ostendorf and Peter Schneck (eds), *Iconographies of Power: The Politics and Poetics of Visual Representation*, Universitätsverlag Winter, Heidelberg, 2003, pp. 65–85

Richard Gould, 'Tolowa', in Robert F. Heizer (ed.), *Handbook of North American Indians: Volume 8, California*, Smithsonian Institution Press, Washington, DC, 1978, pp. 128–36

Florence Curtis Graybill and Victor Boesen, *Edward Sheriff Curtis: Visions of a Vanishing Race*, University of New Mexico Press, Albuquerque, 1976

Yvonne Hajda, 'Southwestern Coast Salish', in Wayne Suttles (ed.) *Handbook of North American Indians: Volume 7, Northwest Coast*, Smithsonian Institution Press, Washington, DC, 1990, pp. 503–17

Bill Holm, 'Art', in Wayne Suttles (ed.), *Handbook of North American Indians: Volume 7, Northwest Coast*, Smithsonian Institution Press, Washington, DC, 1990, pp. 602–32

Bill Holm and George I. Quimby, *Edward S. Curtis in the Land of the War Canoes: A Pioneer Cinematographer in the Pacific Northwest*, University of Washington Press, Seattle, 1980

Edward A. Kennard, 'Hopi Economy and Subsistence', in Alfonso Ortiz (ed.), *Handbook of North American Indians: Volume 9, Southwest*, Smithsonian Institution Press, Washington, DC, 1979, pp. 554–63

Edmund J. Ladd, 'Zuni Economy' in Alfonso Ortiz (ed.) *Handbook of North American Indians: Volume 9, Southwest*, Smithsonian Institution Press, Washington, DC, 1979, pp. 492–98

Margaret Lantis, 'Nunivak Eskimo' in David Damas (ed.), *Handbook of North American Indians: Volume 5, Arctic*, Smithsonian Institution Press, Washington, DC, 1984, pp. 209–23

Lucy R. Lippard (ed.), *Partial Recall*, The New Press, New York, 1992

Christopher M. Lyman, *The Vanishing Race and Other Illusions: Photographs of Indians by Edward S. Curtis*, Smithsonian Institution Press/Pantheon Books, New York, 1982

George I. Quimby, 'Curtis and the Whale', in *Pacific Northwest Quarterly*, vol. 78, no. 4, 1987, pp. 141–44

Leland Rice, *Edward S. Curtis: The Kwakiutl 1910–1914*, (exh. cat.), Fine Arts Gallery, University of California, Irvine, 1976

Edward S. Rogers and James G. E. Smith, 'Environment and Culture in the Shield and Mackenzie Borderlands', in June Helm (ed.), *Handbook of North American Indians: Volume 6, Subarctic*, Smithsonian Institution Press, Washington DC, pp. 130–45

Wayne Suttles, 'Central Coast Salish', in Wayne Suttles (ed.), *Handbook of North American Indians: Volume 7, Northwest Coast*, Smithsonian Institution Press, Washington, DC, 1990, pp. 453–75

Veronica E. Tiller, 'Jicarilla Apache', in Alfonso Ortiz (ed.), *Handbook of North American Indians: Volume 9, Southwest*, Smithsonian Institution Press, Washington, DC, 1979, pp. 440–61

James Van Stone, 'Mainland Southwest Alaska Eskimo', in David Damas (ed.), *Handbook of North American Indians: Volume 5, Arctic*, Smithsonian Institution Press, Washington, DC, 1984, pp. 224–42

I would like to acknowledge a number of individuals who helped on various research and editorial phases of this publication. Interns working with me at the Smithsonian Institution were Eleni Glekas, Andrea Kehler, Daniel Dancis, Kathy Mancuso, Mary Ecker, and Rebecca Simon. Both Raymond J. DeMallie, Department of Anthropology, Indiana University, and Noel P. Elliott, read over the text. Colleagues who helped with specific information include: Douglas R. Parks, American Indian Studies Research Institute, Indiana University; Hugh A. Dempsey, Glenbow Museum; Ives Goddard, Smithsonian; Thomas Kavanagh, Department of Sociology/Anthropology, Seton Hall University, Claudia B. Kidwell, Curator, Personal Appearance in US, Smithsonian; Nicolete Bromberg, Curator of Photographs and Graphics, University of Washington; and Jennifer Brathovde, Library of Congress. A number of Native Americans extended themselves to identify the names of individuals in the photographs: Ramon Riley, Cultural Director, White Mountain Apache Tribe; Perry Chocktoot, Culture and Heritage Dept, The Klamath Tribes; Howard T. Amos, Executive Director, Nunivak Cultural Programs; Malissa Minthorn Winks,

Archives Manager of the Tamástslikt Cultural Institute of the Confederate Tribes of the Umatilla; and Evaline Patt, The Museum at Warm Springs. At Phaidon Press I would like to thank Denise Wolff, Samantha Woods, Paul McGuinness, Mari West and Faye Robson, whose skills brought this book to its final form. I would also like to thank Untitled for the design. This has truly been a group effort.

Phaidon Press Limited
Regent's Wharf
All Saints Street
London, N1 9PA

Phaidon Press Inc.
180 Varick Street
New York, NY 10014

www.phaidon.com

First published 2008
© 2008 Phaidon Press Limited

ISBN: 978 0 7148 4176 2

A CIP catalogue record for this book is available from the British Library.

Designed by Untitled
Printed in China